LEGENDARY LC

OF

QUINCY

MASSACHUSETTS

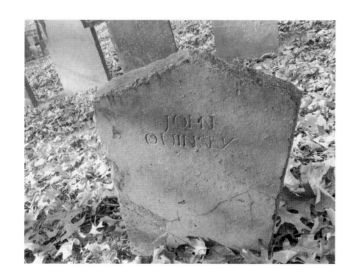

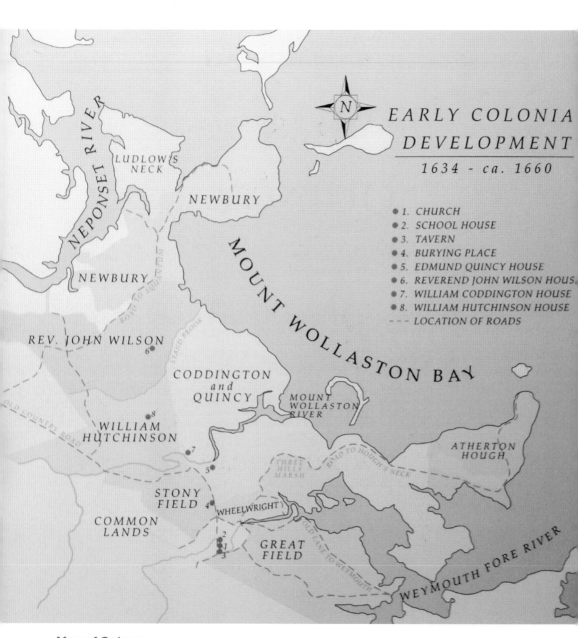

EARLY COLONIAL
DEVELOPMENT
1634 - ca. 1660

- 1. CHURCH
- 2. SCHOOL HOUSE
- 3. TAVERN
- 4. BURYING PLACE
- 5. EDMUND QUINCY HOUSE
- 6. REVEREND JOHN WILSON HOUS.
- 7. WILLIAM CODDINGTON HOUSE
- 8. WILLIAM HUTCHINSON HOUSE
- - - LOCATION OF ROADS

NEPONSET RIVER

LUDLOW'S NECK

NEWBURY

NEWBURY

MOUNT WOLLASTON BAY

REV. JOHN WILSON

CODDINGTON and QUINCY

MOUNT WOLLASTON RIVER

WILLIAM HUTCHINSON

ATHERTON HOUGH

THREE HILLS MARSH

STONY FIELD

WHEELWRIGHT

COMMON LANDS

GREAT FIELD

WEYMOUTH FORE RIVER

OLD COUNTRY ROAD

ROAD TO SQUANTUM

STRAID BROOK

ROAD TO HOUGH'S NECK

OLD LANE TO WEYMOUTH

Map of Quincy

This map shows the original land grants issued in 1634–1635, when what is now Quincy was annexed by Boston. The plots are owned by many of Quincy's indelible names, such as Wollaston, Hough, and Coddington. (Courtesy Quincy Historical Society.)

Page 1: Col. John Quincy

The city of Quincy is named after Col. John Quincy, the grandfather of Abigail Adams. His grave sits tucked away in a cemetery downtown, across the street from the church where Abigail and her family are entombed. The spelling "Quinsey" reflects the headstone's age; there was not a normalized spelling of "Quincy" until well into the 18th century. A more conspicuous stone was installed at the site in 1905. For more information, see page 14. (Author photograph.)

LEGENDARY LOCALS
—— OF ——

QUINCY
MASSACHUSETTS

JACK ENCARNACAO

LEGENDARY
LOCALS

Legendary Locals is an imprint of Arcadia Publishing
Charleston, South Carolina

Printed in the United States of America

Library of Congress Control Number: 2013955329

For all general information, please contact Arcadia Publishing:
Telephone 843-853-2070
Fax 843-853-0044
E-mail sales@arcadiapublishing.com
For customer service and orders:
Toll-Free 1-888-313-2665

Visit us on the Internet at www.arcadiapublishing.com

Dedication
To Ed Fitzgerald, Joe Shea, and Tom Galvin, who generously imparted their knowledge of Quincy's history; and to my beloved wife, Kelly, and son Gray

On the Front Cover: Clockwise from top left:
Edward Monti, granite carver (Courtesy Quincy Historical Society; see page 120), John Adams, second president of the United States (Courtesy Quincy Historical Society; see pages 10, 11), Phyllis Godwin, CEO of Granite City Electric Supply Co. (Courtesy South Shore Chamber of Commerce; see page 53), Uncle Sam Rounseville, living mascot and regular part of parades and civic events, with his grandson, Harry Ryan (Courtesy City of Quincy; see page 104), Josiah Quincy III, Boston's second mayor (Courtesy Quincy Historical Society; see page 16), Lillie Titus, "Grand Lady of Squantum" (Courtesy Quincy Historical Society; see page 123), Walter J. Hannon, mayor (Courtesy City of Quincy; see page 93), Bill Dana, comedian, noted for character "José Jiménez" (Courtesy Evelyn Dana; see page 111), Michael "The Winger" Zadrozny, local curiosity famous for flinging records (Courtesy Phyllis Berlucchi, see page 125).

On the Back Cover: From left to right:
Richard Koch, founder of the "Koch Club" (Courtesy Thomas Koch; see pages 22, 23), employees of Tubular Rivet & Stud, leading Quincy industrial employer from the 1880s to 1960 (Courtesy Quincy Historical Society; see page 56).

CONTENTS

ACKNOWLEDGMENTS

The author is indebted to the work of all Quincy historians, an exclusive and proud lineage. For sharing their personal photographs for this project, I thank Ed Fitzgerald, Frank Bellotti, Evelyn and Bill Dana, Tom Galvin, Robert Brudno, Larry Norton, Tackey Chan, Susan deVarennes, John Stobierski, Louis J. Grossman, the Kandalaft and Djerf families, Joe Shea, Jay Cashman, Phyllis Berlucchi, Chris Walker, David Chew, Bob Noble, and the McGettrick family.

I also wish to thank Megan Allen and Mary Clark at the Thomas Crane Public Library, as well as members of their staff; the Quincy School Department, including Frank Santoro and Richard DeCristofaro; and Mayor Thomas Koch, for sharing materials from their archives.

For permission to publish images from their archival holdings, my sincere thanks go to the Quincy Historical Society, the Thomas Crane Public Library, the South Shore Chamber of Commerce, Dunkin' Donuts, the Grossman Companies, Inc., the Avedis Zildjian Company, and Jay Cashman, Inc.

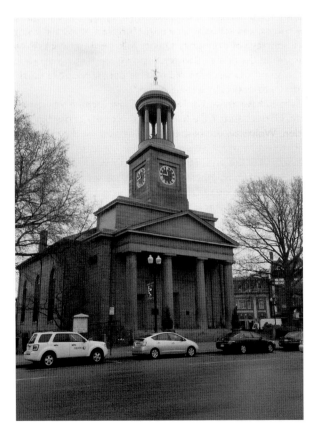

United First Parish Church
The Greek Revival church originally known as the Old Stone Temple was the fourth meetinghouse of Quincy's first congregation. It was designed by architect Alexander Parris, who also designed Boston's Quincy Market. Volunteers offer tours of the church from April to November, including the basement tombs of Presidents John Adams and John Quincy Adams and their wives, Abigail and Louisa Catherine. (Author photograph.)

INTRODUCTION

In a small cemetery next to city hall, in the shadow of the iconic United First Parish Church, where two presidents are entombed, sits the grave of Col. John Quincy. The grandfather of America's second first lady, Abigail Adams, John Quincy was a widely respected Speaker of the Massachusetts House of Representatives in the early 18th century and the man for whom residents named a Braintree precinct that became its own town in 1792.

It is from the bloodlines of this provincial statesman that the "City of Presidents" was birthed. Yet the memory of Colonel John began to fade as Quincy came to be known as the birthplace of patriots like John Adams, John Hancock, and John Quincy Adams. In a 1908 speech, the Reverend Daniel Munro Wilson, pastor of United First Parish Church, decried, "In his day [Quincy] was one of the most trusted and influential public characters of the Province; but, for a hundred years or more, he has now been buried in oblivion. The present generation in Quincy hardly know that such a man ever existed." That disconnect still exists; it is not difficult to find Quincy natives who think their city is named after John Quincy Adams, who was born just a quarter century before Quincy was incorporated.

But in few American cities are the entreaties to honor history so heartfelt and a sense of civic duty so embodied by its residents. Quincy has a proud tradition of lionizing the civic-minded, from business titans to neighborhood fixtures. Their names are emblazoned on street signs, playground plaques, memorial squares, auditoriums, conference rooms, and schools. One might forgive a native for losing track of them all, for there has never been a shortage of exemplary Quincy folk. As Reverend Wilson also noted in 1908, "This, your city of Quincy, from the first settlement till now . . . not one generation has failed to furnish some eminent person, man or woman, who did notable deeds, or spoke timely words, measurably effective in shaping the destinies of the American people."

Quincy's first European settlers are thought to have arrived in 1624 with Capt. Richard Wollaston, about whom little is known. At the time, the Massachusett tribe fished the shores of Quincy Bay and cultivated crops inland. According to tradition, Wollaston established a trading post on the shoreline, and the land his followers inhabited was christened Mount Wollaston. Another European settler who accompanied Wollaston, Thomas Morton, later called the land "Mare Mont," Latin for "hill by the sea." That morphed into Merrymount, a moniker that spoke to Morton's penchant for making merry and trading firearms with the natives. Today, Merrymount is one of Quincy's tidiest neighborhoods.

Beginning in 1634, the Massachusetts Bay Colony began issuing the first land grants to prominent men in what is now Quincy. Among them were Atherton Hough, namesake of Houghs Neck, William Coddington, future governor of Rhode Island and Quincy's first significant benefactor, and Edmund Quincy I, whose son Edmund II built the landmark Quincy Homestead in 1685. In 1706, Edmund III expanded the homestead into a grand mansion, later known as the Dorothy Quincy Homestead because it was the childhood home of John Hancock's wife. The mansion still stands at the corner of Hancock Street and Butler Road.

In 1639, the Reverend William Tompson formed a congregation at Mount Wollaston, the first church in Quincy. That resilient congregation built the picturesque First Parish Church in 1828, financed by parish member John Adams. Formally known today as the United First Parish Church (Unitarian), the "Church of Presidents" hosts the tombs of John, Abigail, John Quincy, and Louisa Catherine Adams.

Quincy was still known as Braintree's North Precinct in 1735 when John Adams was born in a saltbox-style home on the corner of what are now Franklin Street and Independence Avenue. In 1787, John and Abigail Adams acquired the Peacefield mansion and farm that is at the heart of the Adams National Historic Park. Generations of Adamses were born and bred in Quincy, all the way through Charles Francis Adams III, the mayor of Quincy from 1896 to 1897, the year before it officially became a city.

In the early to mid-19th century, a wave of European immigrants arrived in Quincy to work in its granite quarries. The quarries' lucrativeness exploded due to the mechanical innovations of builder Solomon Willard, who constructed Boston's famed Bunker Hill Monument using granite from Quincy. In short order, the phrase "Quincy granite" signaled sturdiness and quality across the country, and it was used in a number of prominent edifices. Entrepreneurs were drawn to the city from far and wide, and the legal rights to quarry land were coveted. At the industry's height, there were as many as 54 working quarries in Quincy. Technological advances slowly chipped away at the industry, and the once ubiquitous granite sheds were scant by the 1960s.

As the world wars dawned, quarrying was supplanted by shipbuilding as Quincy's industrial calling card. The Fore River Shipyard was founded by Thomas Augustus Watson, the famed inventor who partnered with Alexander Graham Bell in the creation of the telephone. Bethlehem Steel Corporation purchased the yard in 1913 and received an initial order from the US Navy for 28 destroyers, 15 submarines, and battle cruisers. In 1963, the shipyard was purchased by General Dynamics, who operated it until it closed in 1986. Like granite quarries, the shipyard attracted legions of newcomers to Quincy for job opportunities. As many as 32,000 people were employed at the shipyard at its height, and descendants of shipyard workers still heavily populate Quincy Point.

Quincy also has a distinguished history in the retail and service industries. Known as "Shopperstown USA" in the 1950s and 1960s for its bustling downtown, the city is the birthplace of Dunkin' Donuts, Howard Johnson's, and Grossman's Lumber & Building Supply. Today, Quincy is a distinct blend of old lineages and new demographics. The city has more Asian residents per capita than any community in Massachusetts, including Boston, and is the home base for entrepreneurs in everything from tee shirt design to Asian cuisine.

Through it all, the city's mothers and fathers have honored Quincy's history, one characterized by fidelity to the city, to the nation, and to each other. One would like to think the Reverend Daniel Munro Wilson would be proud, even if Col. John Quincy's name still does not strike much of a chord.

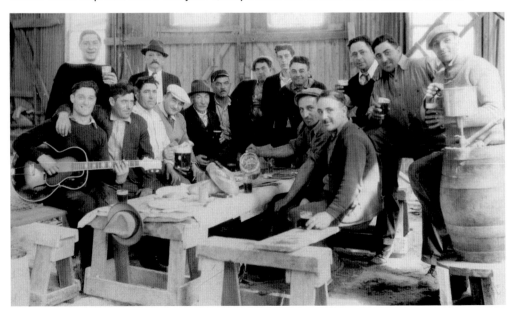

Granite Workers, E. Settimelli & Sons
In the months of April and May, workers in Quincy's granite sheds labored day and night to get product out in time for Memorial Day, when cemeteries teemed with visitors. In this photograph taken on May 29, 1936, workers at E. Settimelli & Sons, which operated on Totman Street in West Quincy, celebrate the end of the of the holiday rush. (Courtesy Quincy Historical Society.)

CHAPTER ONE

City of Presidents

In the 1630s, two English settlers arrived on Quincy's shores and set down roots that would shape the nation. John Adams Sr. came from Essex. Edmund Quincy and his son Edmund II came from Northamptonshire. Adams purchased a farm and built a home in the area that is now South Quincy. Quincy and his son, along with William Coddington, purchased one of the original land grants along the Wollaston shoreline and established a homestead near what is today Butler Road.

John Adams Sr. and his wife had three sons, including the second president of the United States, also named John. One of Edmund Quincy's daughters, Elizabeth, married the Reverend William Smith of nearby Weymouth, and the couple had a daughter named Abigail. In 1764, John Adams and Abigail Smith were wed, the beginning of a symbiotic, resolute relationship later chronicled in books and even an HBO miniseries. Separately and as a unit, John and Abigail represented the heart of the American Revolution, with their love for each other and the patriotic cause spelled out poetically in letters exchanged while John traveled. One of the couple's six children, John Quincy Adams, the sixth president of the United States, was raised in Quincy, and he returned to the city after his term ended to represent his hometown in Congress. The family also produced US cabinet secretaries, a Massachusetts governor, and congressmen.

Descendants of both the Adams and Quincy families made indelible contributions to the fledgling United States. From the roof of a home he built on what is today Murihead Street, Col. Josiah Quincy kept tabs on British warships in Boston Harbor and corresponded with Gen. George Washington. Josiah Quincy III became president of Harvard University, was mayor of Boston, and is the namesake of Boston's landmark Quincy Market. Josiah III's son and grandson were also Boston mayors. Dorothy Quincy married John Hancock, who, as governor, affixed his renowned signature to the act that incorporated Quincy as a town.

From local homesteads to the White House, these Quincy clans shaped the nation.

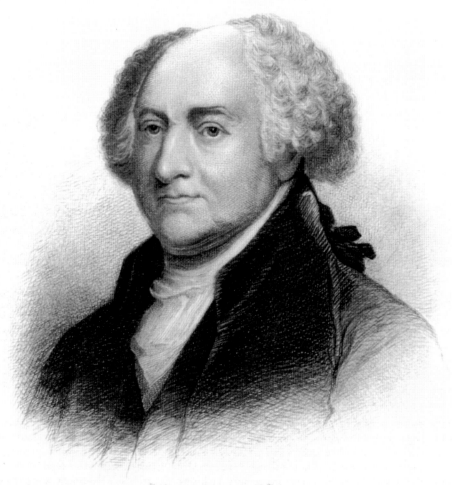

Eng.d by H.B.Halls Sons New York

John Adams

John Adams

As far afield as his exploits took him, John Adams never forgot Quincy, and he was keenly interested in shepherding a good future for it. In 1822, a quarter-century after he had left the White House, Adams donated two tracts of land to Quincy and decreed that the profits from their use would go to building a church and a school: the Adams Academy and the United First Parish Church. In his deed for the school, Adams offered specific instructions for teachers, including that students repeatedly write the Greek and Hebrew alphabets. This, Adams wrote, "will be as good an exercise in chirography as any they can use, and will stamp those alphabets and characters upon their tender minds and vigorous memories so deeply that the impression will never wear out." The imprint Adams made on his hometown is not likely to wear out, either. His birthplace, a humble abode in the New England saltbox style, still stands on the corner of Independence Avenue and Franklin Street (left). One of the most important legal minds in American history, Adams and fellow patriots Samuel Adams and James Bowdoin crafted the seminal Massachusetts constitution in the home next door to his birthplace, where he lived with his wife, Abigail, and raised his children. Adams lived out his days on the picturesque Peacefield estate on Adams Street, on which sits the handsome Old House, the Adams family residence for generations and the first summer White House. Adams saw to it that his books and papers were preserved in a fireproof building on the property, known as the Stone Library. Visitors from around the world tour the property today, but one can imagine Adams being most heartened to see Quincy schoolchildren there on field trips, roaming the halls and fields where he reflected on a new nation and his indelible contributions to it. (Left, courtesy Quincy Historical Society; above, courtesy Library of Congress.)

Abigail Adams

On June 17, 1775, Abigail Adams and her son John Quincy scaled Penn's Hill to watch smoke rise and cannons fire during the Battle of Bunker Hill, a turning point in the American Revolution. She wrote the following day to her husband, John, then a traveling diplomat, "The day, perhaps the decisive day is come on which the fate of America depends. My bursting heart must find vent at my pen." It was one of many correspondences between Abigail, an intelligent and resilient daughter of a clergyman, and John Adams. Their eloquent, heartfelt letters provided a window into the Revolution's emotional backdrop. A cairn built in 1896 on Franklin Street (below) marks the spot where Abigail and her son, a future president himself, took in the historic battle. (Right, courtesy Quincy Historical Society; below, courtesy City of Quincy.)

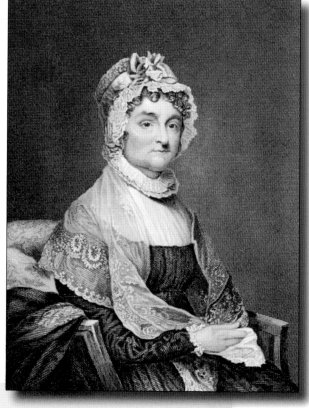

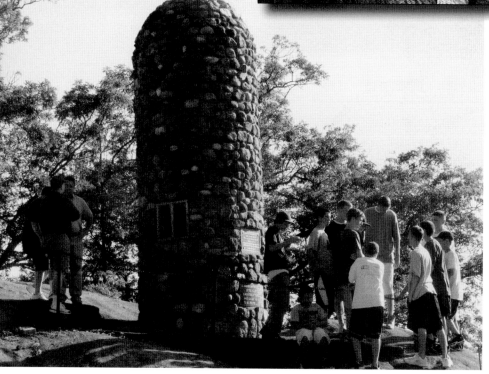

John Quincy Adams

The second child of John and Abigail Adams was America's first second-generation president. John Quincy Adams was immersed as a boy in the spirit of the fledgling nation, of which he would be president from 1825 to 1829. He returned to Quincy after his presidency to practice law, walking to his office at what is today old city hall. (Courtesy Quincy Historical Society.)

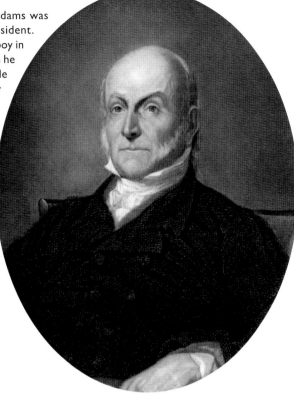

Louisa Catherine Adams

The wife of John Quincy Adams was a bit of an outsider in the first family and is the subject of great curiosity among historians. Born in London, she introduced a decidedly non-Yankee disposition to the family and was revered for her 40-day winter journey across Europe with her baby son to join her husband. She lived out her years in Washington; the family had her transported to Quincy for burial. (Courtesy Quincy Historical Society.)

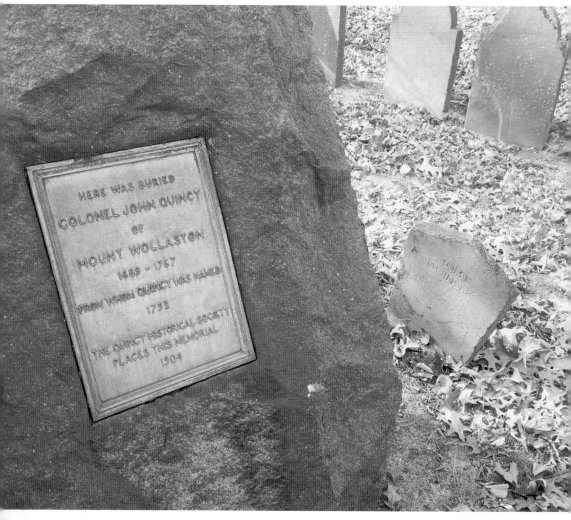

HERE WAS BURIED
COLONEL JOHN QUINCY
OF
MOUNT WOLLASTON
1689 - 1767
FROM WHOM QUINCY WAS NAMED
1792
THE QUINCY HISTORICAL SOCIETY
PLACES THIS MEMORIAL
1904

JOHN QUINCY

Col. John Quincy

Dubbed the "civic father of Quincy" and "Master of Mount Wollaston," the grandfather of Abigail Adams was a revered figure in provincial Massachusetts. Col. John Quincy was a member of the Massachusetts House of Representatives from 1719 to 1740 and the speaker of the house for all but seven of those years. He was the longtime town moderator in Braintree, which Quincy was a part of prior to seceding. Though prominent and influential in his day, none of Quincy's papers or letters ended up in the possession of his descendants, and there are no known visual representations of him. Quincy lived most of his life in a home on the road that led to Houghs Neck and Germantown. While deemed "Colonel," a ceremonial title, he was actually a major in the Suffolk regiment of his uncle, Lt. Col. Edmund Quincy. A movement began around 1728 to break off Braintree's North Precinct as its own town, and thus began the quest for a town name. Richard Cranch, a postmaster who married Abigail Adams's sister, officially recommended naming the town after Colonel Quincy, who at one point chaired a committee that considered if there would be an advantage to dividing Braintree in two. The Town of Quincy was incorporated in 1792, a quarter-century after Colonel Quincy's death. No one knew where he was buried until 1903, when a fragment of what was thought to be his headstone was found in an old burial ground (now Hancock Cemetery) next to city hall. A more conspicuous marker was installed the next year by the Quincy Historical Society, an understated tribute to the city's namesake. (Author photograph.)

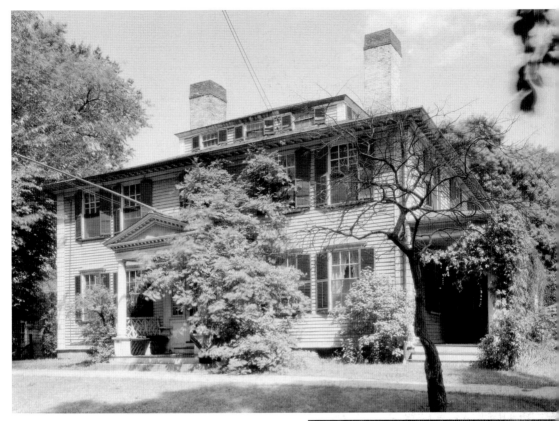

Col. Josiah Quincy

When Col. Josiah Quincy built a mansion overlooking Quincy Bay in 1770 (pictured here around 1934), he set down roots for a progeny that would become architects of America. Quincy obtained his fortune when a ship his firm owned tricked a Spanish ship to surrender its booty. From his roof, Quincy monitored British troops in Boston Harbor and advised Gen. George Washington of their movements. (Courtesy Library of Congress.)

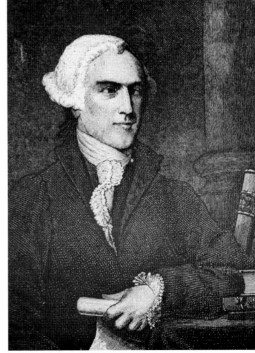

Josiah Quincy Jr.

A gifted lawyer, orator, and propagandist, Josiah Quincy Jr. brought the Quincy name to a new prominence. He was cocounsel with John Adams in the Boston Massacre trial, traveled to England to plead the American cause, and died of tuberculosis during his return trip at age 31, one month before the battles at Lexington and Concord. Adams later called him "as ardent a patriot as any of his age." (Courtesy Thomas Crane Public Library.)

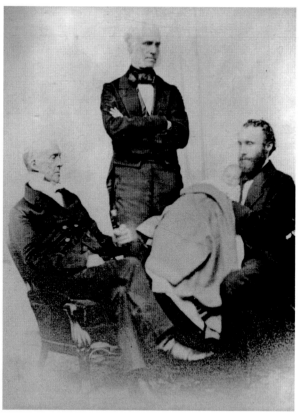

Josiah Quincy III, IV, V, VI
As America dawned, the Quincys became one of Massachusetts's leading families. Josiah Quincy III (left) was Boston's second mayor and the namesake of Quincy Market. His son Josiah IV (center) was also a Boston mayor. His other son, Josiah V (right, holding baby), was a prominent lawyer. The baby is Josiah VI, also a future Boston mayor. (Courtesy Quincy Historical Society.)

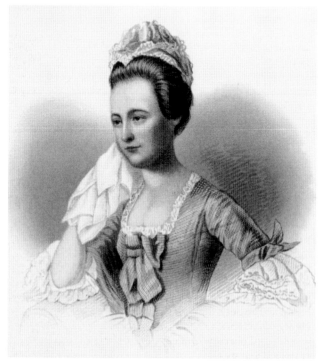

Dorothy Quincy
Known as the "first First Lady of Massachusetts," the self-assured Dorothy Quincy, who married Gov. John Hancock in 1775, was raised in a home at the corner of what are today Hancock Street and Butler Road. The home is a blend of architectural styles due to additions by Dorothy's storied ancestors, including her aunt, also named Dorothy, about whom Oliver Wendell Holmes wrote the poem "Dorothy Q." (Courtesy Quincy Historical Society.)

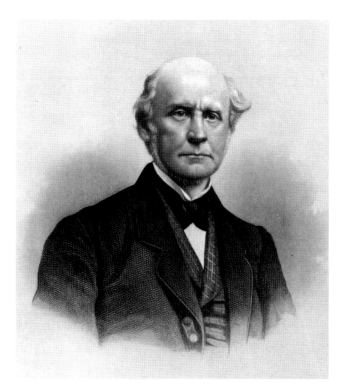

Charles Francis Adams Sr. The son of Pres. John Quincy Adams was a cagey ambassador to England during the Civil War and is usually credited with keeping England neutral. He retired to the family homestead in Quincy after the war, perhaps illustrating one of his famous quotes: "In this country . . . men seem to live for action as long as they can and sink into apathy when they retire." (Courtesy Quincy Historical Society.)

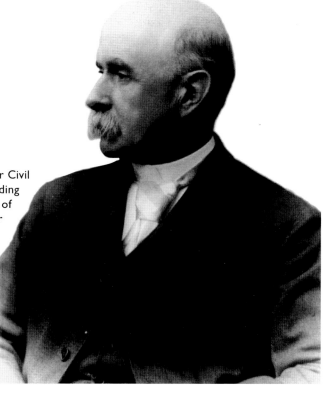

Charles Francis Adams Jr. Adams fought in a number of major Civil War battles and was also a crusading journalist. He became president of the Union Pacific Railroad after chronicling corruption in the industry. Adams had a knack for publicity and speechmaking. As a school committeeman, he hired the dynamic Francis Parker as Quincy's first superintendent, led the foundation of the Quincy Historical Society, and gifted Merrymount Park to Quincy in 1885. (Courtesy Quincy Historical Society.)

JOHN QUINCY ADAMS, 2D

Charles Francis Adams III

Charles Francis III is the last Adams who served Quincy in an elected capacity. The former navy secretary was the youngest mayor in Massachusetts when he was elected in 1896 at age 27. An avid yachtsman, Adams was once a director at the Quincy Yacht Club. His son Charles Francis IV founded the defense contractor Raytheon. (Courtesy Quincy Historical Society.)

John Quincy Adams II

The grandson of the sixth president largely looked after the family's interests in Quincy. Many of the signatures attributed to his grandfather are actually his. Along with brother Charles Francis Jr., Adams developed the Tudor-style Adams Building in Quincy Center. Much of his property was subdivided after his death, including the eponymous Adams Shore area. (Courtesy Quincy Historical Society.)

BROOKS ADAMS

Brooks Adams

If every family has a rascal, then this son of Charles Francis Adams Sr. was it for the Adamses. Peter Chardon Brooks Adams was infamous for his oddball countenance and for making awkward remarks at dinner parties. It is perhaps fitting that the Harvard Law graduate's signature work is entitled *The Law of Civilization and Decay*, a theory of history hailed for its prescient insights into what fallen civilizations share in common. A young woman who once turned down his marriage proposal was met with a sharp response: "Why you perfect damn fool." Brooks was the last Adams to live in the Old House at Peacefield (below), which he restored and prepared for becoming a museum. It was donated to the National Park Service in 1947. He had no children. (Right, courtesy Quincy Historical Society; below, courtesy Library of Congress.)

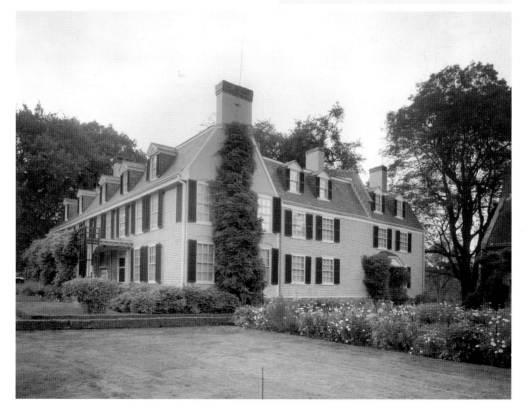

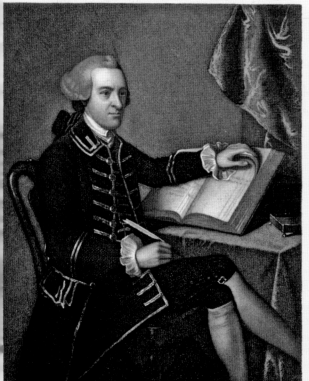

Engraved by I.B.Forrest

JOHN HANCOCK,

John Hancock

The owner of America's most famous signature has noteworthy connections to Quincy. He was born in a home situated roughly where the Adams Academy sits on Hancock Street, a simple country colonial that burned down in the late 1750s. A granite bust of Hancock (below) marks the spot today. Hancock's father, a minister, died when he was boy, so he was raised by his wealthy uncle on Boston's Beacon Hill. Despite spending his formative years in Boston, Quincy has always claimed Hancock. In fact, at the 1792 town meeting where Quincy was selected as the new name for Braintree's north precinct, another name was enthusiastically floated for consideration: Hancock. (Left, courtesy Quincy Historical Society; below, author photograph.)

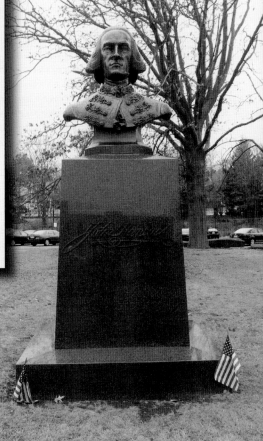

CHAPTER TWO

City of Service

Quincy's role in American history instills a sense of pride and duty in its sons and daughters. From the battlefield to the pulpit, those who have most proudly called Quincy home have given back, and city leaders have always considered it an essential part of their jobs to lionize the selfless among them.

Quincy boasts one of the largest and longest-running Flag Day parades in the country, conceived by community stalwart Richard Koch, whose "Koch Club" program provided structure and recreational opportunities for generations of youngsters. Koch combined a desire to help with the know-how to see it through, qualities shared by many of the city's most beloved servants. Fr. William "Bill" McCarthy and Dr. Charles Djerf saw needs among the city's homeless and drug-addicted and created the brick-and-mortar programs to meet them.

On the battlefield, Quincy has given a great deal. Two Congressional Medal of Honor winners for heroics in World War II, Everett Pope and William Robert Caddy, graduated from North Quincy High School, which venerates all alumni who have served in its "Atrium of Honor." Quincy has also known the burden of service in wartime. During Vietnam, the nation got one of its first glimpses into North Vietnamese prisoner camps via a photograph in *Life* magazine of captured Quincy native Richard Stratton being forced to bow to an enemy commander. Stratton was imprisoned from 1967 to 1973 and suffered alongside the likes of Sen. John McCain and fellow Quincy native E. Alan Brudno, who met a tragic end after returning home.

Others have devoted their lives to preserving Quincy's history. H. Hobart Holly, Edward Fitzgerald, and Thomas Galvin have meticulously collected and archived photographs and documents that provide important glimpses of the ever-changing city. Decades-long clerks like John Gillis and Joseph Shea considered it their calling to preserve city records before they were viewed as historic.

Through the generations, Quincy folks of all stripes have answered the call to serve, giving of their time, treasure, talents, and lives to ideals this formative American city has always represented.

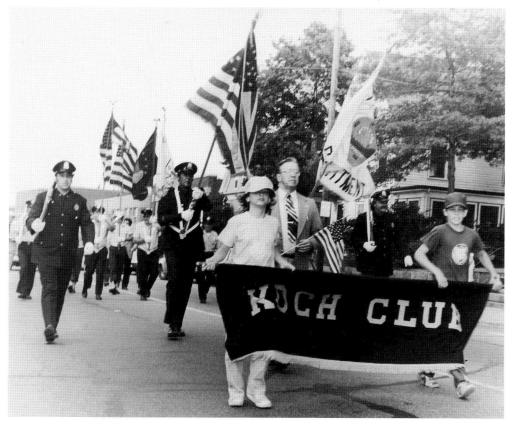

Richard Koch

Those who grew up in Quincy in the 1950s, 1960s, and 1970s most likely played Little League in the Koch Club and waved miniature Old Glories in the club's annual Flag Day parade. The force behind it all was Richard Koch, a milkman who dedicated his life to caring for Quincy's parks and keeping kids off street corners. Koch graduated from North Quincy High School in 1942 and, after serving in World War II, worked at White Brothers Milk and Whiting Milk Co., running the companies' wholesale and trailer shipping operations. He sensed a void of organized recreation in Quincy and, in 1948, started the Koch Club, an outgrowth of a North Quincy social club of which he was the most active member. The initial Koch Club consisted of 30 men playing intramural softball at Cavanagh Stadium. Its signature boys' baseball league was added in 1951, structured to Koch's credo: "Every boy plays in every game." A girls' softball team was added in 1952 and directed by his wife, Simone. The club welcomed all ages to its various sports; members in their 70s took up couples bowling. The self-supporting Koch Club also maintained its own blood bank and made home visits to shut-ins around Christmas. The club's first Flag Day parade stepped off in 1952, walking a route from Quincy Square to Veterans Stadium, where an especially large flag was raised. The parade continues today as a signature Quincy event under Koch's son Mayor Thomas Koch. Richard Koch was active in politics and is credited as being one of the people most responsible for tilting the largely Republican city Democratic in the 1960s as well as bolstering the city party. The Koch Club has only one honorary member, Pres. John F. Kennedy, who donned a Koch Club hat during a 1958 visit to Quincy as part of his US senate campaign. It was said to be the only time Kennedy was ever photographed wearing a hat. Koch died at age 64 in 1987 of natural causes, prompting a flood of tributes across the city, including the dedication of the Richard J. Koch Family Recreation Complex on Merrymount Parkway. (Both, courtesy Thomas Koch.)

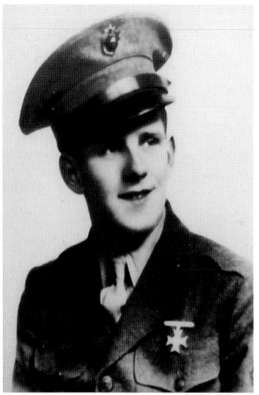

William Robert Caddy
Caddy, a Marine who attended North Quincy High School from 1938 to 1942, received a posthumous Congressional Medal of Honor for diving on a live grenade that landed in a shell hole he and his comrades took cover in during the Battle of Iwo Jima. The act of valor cost the 19-year-old his life but saved those of his platoon leader and fellow servicemen. (Courtesy Larry Norton.)

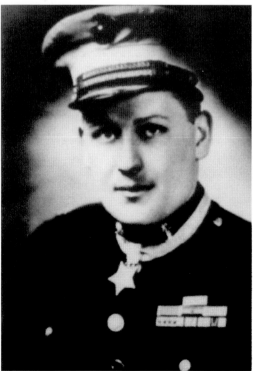

Everett Pope
The first soldier awarded the Medal of Honor by President Truman, Pope graduated from North Quincy High School in 1937 and enlisted in the Marines. During a battle on the island of Peleliu, Pope found himself outnumbered and outgunned, so he resorted to throwing rocks and fists to fend off enemies. He survived the siege and returned home to work as a banker. He died in 2010 on his 90th birthday. (Courtesy Larry Norton.)

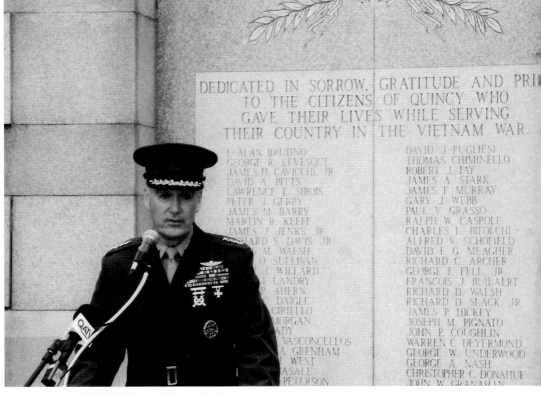

DEDICATED IN SORROW, GRATITUDE AND PRI
TO THE CITIZENS OF QUINCY WHO
GAVE THEIR LIVES WHILE SERVING
THEIR COUNTRY IN THE VIETNAM WAR.

P ALAN BRUDNO DAVID J PUGLIESI
GEORGE R LEVESQUE THOMAS CHIMINELLO
JAMES H CAVICCHI JR ROBERT J FAY
DAVID A PFEFS JAMES A STARK
LAWRENCE E SIROIS JAMES F MURRAY
PETER J GERRY GARY J WEBB
JAMES M BARRY PAUL V GRASSO
MARTIN R KEEFE RALPH W CASPOLE
JAMES J JENKS JR CHARLES L BIEOLCHI
ARD S DAVIS JR ALFRED V SCHOFIELD
M WALSH DAVID E G MEAGHER
O SULLIVAN RICHARD C ARCHER
WILLARD GEORGE F FELL JR
LANDRY FRANCOIS J BUILAERT
AHERN RICHARD D WALSH
DAIGLE RICHARD D SLACK JR
CIRIELLO JAMES P HICKEY
ORGAN JOSEPH M PIGNATO
ADY JOHN P COUGHLIN
VASCONCELLOS WARREN C DEYERMOND
A GRENHAM GEORGE W UNDERWOOD
WEST GEORGE A NASH
ASALE CHRISTOPHER C DONAHUE
PETERSON JOHN W GRANAHAN

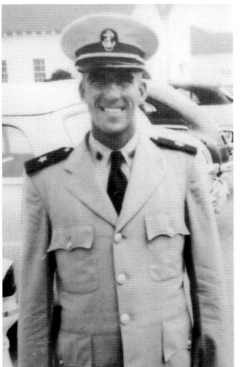

Joseph Dunford Jr.

Dunford attained the highest rank any Quincy serviceman has when, in 2013, he took command of the NATO-led mission in Afghanistan. A four-star general and former assistant commandant, Dunford was given the nickname "Fighting Joe" for leading a Marine regiment in the especially perilous early days of the second Iraq war. Dunford has made several trips back to Quincy, where his parents still live. (Courtesy Larry Norton.)

Richard Stratton

Navy captain Richard Allen Stratton, who attended North Quincy High School, spent 2,251 days in the "Hanoi Hilton" prison camp during Vietnam. A *Life* magazine photograph of him bowing to the North Vietnamese shocked America and drove home the dire nature of the war. Fellow prisoner John McCain recalled tapping quadratic alphabet messages with Stratton from his cell. Stratton returned in 1973 and settled in Florida. (Courtesy Larry Norton.)

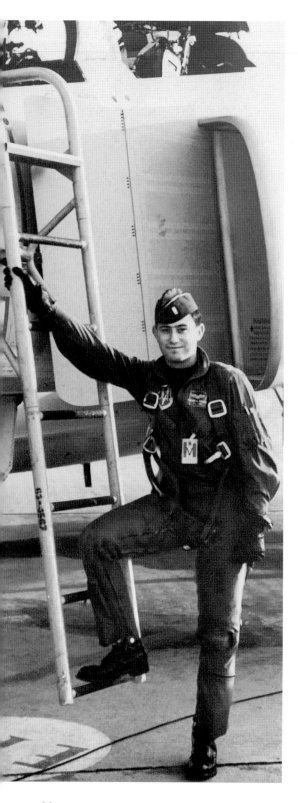

E. Alan Brudno

Few veterans so vividly illustrate the psychological toll of war as Quincy's Edward Alan Brudno. The son of a Quincy family doctor, Brudno aspired to be an astronaut, so, after graduating from North Quincy High School in 1958, he attended the prestigious Massachusetts Institute of Technology to study electrical engineering. He was told the quickest path to the astronaut program was through the Air Force, so he joined, and he was soon an F-4 Phantom pilot. He was deployed to Thailand a few months after he was married. Brudno's plane was shot down over Vietnam in 1965, and he was taken captive for 2,675 days, one of the longest Prisoner of War (POW) stints an American has endured. In the camp, Brudno was forced to read newspaper stories about American bombing missions over a loudspeaker as a form of propaganda. Brudno was beloved by his comrades for undercutting his captors' aims by altering the words and phrases he read to humorous effect—"Ho Chi Minh," for example, became "Horse [Expletive] Minh." Back in Quincy, Brudno's father agonized over his son and was known to ask, without prompting, "What are they doing to my Alan?" Brudno returned home in 1973. Four months later, he committed suicide, the first released Vietnam POW to die. His brother Robert wrote in a 2005 tribute speech, "As one military psychiatrist explained it to me many years later, he just used up everything he had over those long years in captivity. There was no strength left with which to survive." Brudno added, "Some years ago, I told a former POW that sometimes I think it would have been better for Alan and his family if he had just been blown out of the sky back in 1965. To have survived so much for so long and then to have him slip through our fingers seemed to be so cruel. The other POW looked at me and said, 'But then WE wouldn't have had him.' Then, I understood that he meant a lot to others while he was a captive." Robert Brudno, himself a veteran, fought to have his brother's name added to the Vietnam Memorial Wall in Washington, DC, which it was in on Memorial Day in 2004. Alan Brudno was awarded two Purple Hearts, and his tragic story opened an important dialogue about veterans' psychological health. (Courtesy Robert Brudno.)

Charles Sweeney
North Quincy High School graduate Charles Sweeney was a big presence and a boisterous storyteller, and he had quite a story to tell. As a 25-year-old Air Force officer during World War II, Sweeney piloted the B-29 bomber that dropped an atomic bomb on the Japanese city of Nagasaki, prompting the Japanese surrender. Sweeney made the call to drop the bomb on Nagasaki because clouds obscured the original target, Kokura. The bomb, called "Fat Man," killed some 40,000 people. Sweeney returned home and told his story to generations in classrooms, lecture halls, and veterans' posts. "It was the only time this weapon has been used in warfare, and I hope it's the last time," Sweeney told a fraternal organization in 1993. He was outspoken in defense of the bombing when its necessity was questioned decades afterward. Sweeney died in 2004 at age 84. (Courtesy Larry Norton.)

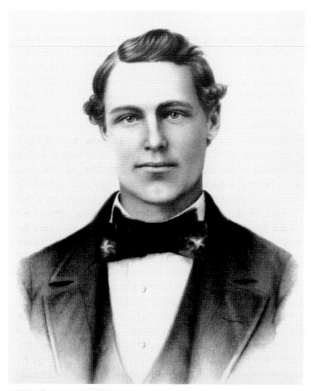

Francis Lincoln Souther
Francis Lincoln Souther, killed in battle at age 25 on June 10, 1861, was the first soldier from Massachusetts to die in combat during the Civil War. He came from a prominent family of Quincy industrialists. The Souther Tide Mill, on Southern Artery, is named for his family, who used the tide to generate power for a gristmill. (Courtesy Quincy Historical Society.)

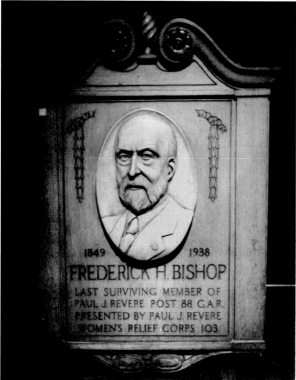

Frederick Bishop
Comdr. Frederick Bishop was the last surviving member of Quincy's Paul J. Revere Post, which was established by Civil War veterans from the city. Bishop, who lived to age 90, was charged with closing other Civil War–era posts as veterans passed away, and he took care to preserve relics and records. He died in 1921. Bishop Playground in Montclair is named in his honor. (Courtesy Quincy Historical Society.)

Charles Djerf

Dr. Charles Djerf was a friend to the comfortable and the afflicted alike. A pediatrician with a musical bent, Djerf founded the Quincy Symphony Orchestra and served on the school committee from 1953 to 1969. He was one of the first doctors to proactively treat drug-dependent people in Quincy, a highly controversial pursuit in his time. In 1970, Djerf told the *Boston Globe* about his distress at not knowing how to treat a 17-year-old girl brought to him unconscious after injecting drugs. "This showed me how ignorant I was," Djerf said. "The medical profession has been indolent . . . not accepting its social responsibility." Djerf teamed up with local officials and treatment professionals to form Survival, Inc., an agency that staffed nurses and other addiction-treatment professionals; all were responding to Mayor James McIntyre's 1971 call for a "supreme effort to control and to rid our community of this dreaded evil," drug addiction. Survival, Inc., managed a hotline, a walk-in center, and therapy and methadone programs. Born in southwest Quincy to Finnish immigrants, Djerf was a hero to the local Finnish community, who admired his rise from Quincy schools to Tufts Medical School, where he served as a trustee later in life. Djerf graduated from Quincy High School in 1928 and opened his practice in 1939, operating continuously for more than 30 years, pausing only for a tour in the Navy. He was beloved as the doctor to what seemed like all of Quincy's children, and the city's political class often feared Djerf would make a serious run for mayor, but that was not in his nature. Djerf instead served in a litany of civic capacities and was on the staffs of Quincy City Hospital, Massachusetts General Hospital, and New England Medical Center. After his death at age 62 in 1973, Mayor McIntyre called Djerf "a true humanitarian who literally gave his life for our community and children. . . . Fearless in his devotion to what he saw was right, he often rushed into controversy, but always stayed committed to his ideals until he saw his cause completed." Djerf's kin also made important contributions to Quincy. His late son Charles Jr. taught algebra in the school system for four decades and was minted "the Voice of Quincy" for his 47 years of announcing high school football games. (Courtesy the Djerf family.)

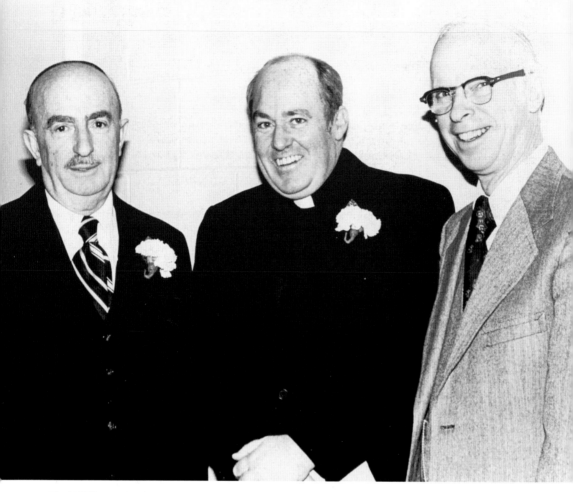

Fr. William McCarthy

Perhaps no other Quincy mainstay embodied charity quite like Fr. William McCarthy (center), known affectionately as "Father Bill." The pastor of St. John's Church, McCarthy founded Father Bill's Place in 1984, a refuge for the city's homeless that grew from a bare-bones shelter in a church basement to a nationally recognized service agency. McCarthy worked tirelessly, connecting thousands with nowhere to turn with everything from a hot meal to an apartment. He was also very savvy, a master at working Quincy's social and political scene to secure the donations needed to keep his shelter running. One was loathe to decline his entreaties, for Father Bill walked the walk. He was known to peel off his coat and give it to someone on the street who looked like he needed it. McCarthy died in 2009 at age 82. To the left of McCarthy is Rabbi Jacob Mann of Beth Israel Synagogue. To the right is Rev. John Banks, pastor of Bethany Congregational Church. (Courtesy Quincy Historical Society.)

Opposite Page: Larry Norton

Norton (right), a Germantown resident and Vietnam veteran, is president of the Vietnam Combat Veterans Combined Armed Forces Quincy Chapter. He made it his life's mission to dedicate a square in Quincy for all 38 city natives who died in Vietnam, a mission he completed in April 2014 when a corner on Billings Road was dedicated to Marine Martin R. Keefe. At left is Tom Bolinder, a retired Quincy police lieutenant and Vietnam veteran. (Courtesy Larry Norton.)

Robert and Gloria Noble

World War II veteran Robert Noble and his bride, Gloria, moved to Quincy in 1952 and quickly began their decades of service to the city. Gloria (second from left) first joined the Wollaston Mothers Club, and she was soon directing the Domestic Violence Ended (DOVE) program for battered women. Bob (third from left), an engineer and photographer, has snapped group pictures at community events for decades. Gloria died in 2013, after a long illness, at age 87. At left is Roger White, Bob and Gloria's son-in-law and a Quincy police officer. (Courtesy City of Quincy.)

Henry Bosworth

Bosworth's *Quincy Sun*, the city's beloved weekly newspaper, launched in 1968 and has provided a flavor of hometown coverage residents hold dear. A career beat reporter, the gregarious Navy veteran famously quit the baseball team in high school to write the school paper. Bosworth was often a one-man show, working every Saturday to hit the midweek deadline. His son Robert took the reins after Henry's death at age 85. (Courtesy Quincy Historical Society.)

William Flynn

It was said that no one knew Quincy like Bill Flynn (center). The *Patriot Ledger*'s city editor understood the ties that bind people from Quincy, even when the day's political drama seemed to create unbridgeable divides. Salty, worldly, and compassionate, Flynn held court during Saturday morning breakfast roundtables on pressing issues and penned the must-read "City Seen" column in the *Ledger*. He died unexpectedly from a heart attack in 2004 at age 57. At left is Tom Feenan, a Quincy financial planner, and at right is Bob Galligan, a Quincy restaurant owner. (Courtesy Thomas Galvin.)

Paul Reardon
Justice Paul Cashman Reardon served on the Massachusetts Supreme Judicial Court and is credited with establishing a host of important rules, including ones to stave off prejudicial pretrial publicity. Reardon developed his rhetorical chops as a member of the Quincy High School debate team, and he was a founding member of the National Conference of State Trial Judges and the National Center for State Courts. (Courtesy Quincy Historical Society.)

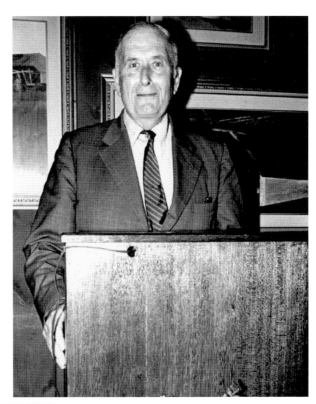

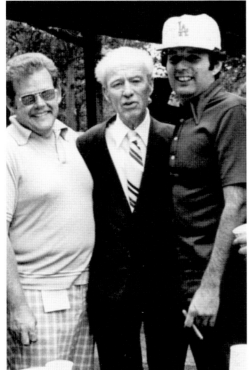

Dennis Ryan
The clerk of courts in Quincy from 1951 to 1980, Ryan (center) served as a trusted community disciplinarian remembered for reforming offenders, particularly youth, just as much he penalized them. Diminutive and always full of energy, Ryan was also a father of the Democratic Party in Quincy, heading a headstrong group who repeatedly sought office. He died in 1981 at age 70. The road that runs along his former office at Quincy District Court is named after him. At left is Ed Masterson, and at right is Louis Bertucci, both Quincy attorneys. (Courtesy Quincy Historical Society.)

H. Hobart Holly

Henry Hobart Holly was an institution at the Quincy Historical Society, where he was director from 1955 to 1975. A stickler for detail with an encyclopedic knowledge of Quincy history on par with anyone, Holly came to Quincy from New York to work at the Fore River Shipyard as an engineer after World War II. He died in 1992 at age 86. (Courtesy Quincy Historical Society.)

Edward Fitzgerald

Few work as tirelessly to keep Quincy's history alive, relevant, and vibrant as Dr. Edward Fitzgerald, director of the Quincy Historical Society. A doctor in 19th-century American literature, Fitzgerald regularly hosts community talks on the Adamses and lesser-explored subjects such as Quincy's Civil War contributions. (Author photograph.)

Thomas Galvin and Sons

City historian Thomas Galvin (at right, with Bill Clinton) is an authority on how the granite industry influenced Quincy's history, and he provided historical context for his sons as they developed former granite sheds into housing, remaking their native West Quincy. Galvin was vice president of Boston Gear Works, one of Quincy's largest industrial employers, and president of the South Shore Chamber of Commerce. Galvin is pictured chatting with Clinton, who was governor of Arkansas at the time; the "President's Table" placard referred to Galvin's position at the chamber. Below, Galvin is pictured third from left with sons Sean (far left), Thomas Jr. (second from left), and Scott (far right). Sean and Scott Galvin have operated a successful development company in Quincy for 20 years and own the landmark Adams Inn, which Thomas Jr. manages. (Both, courtesy Thomas Galvin.)

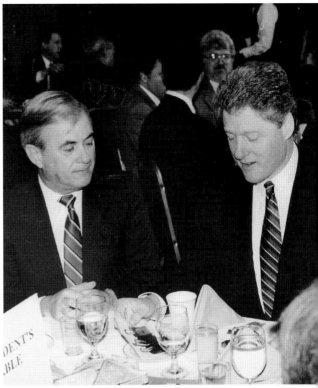

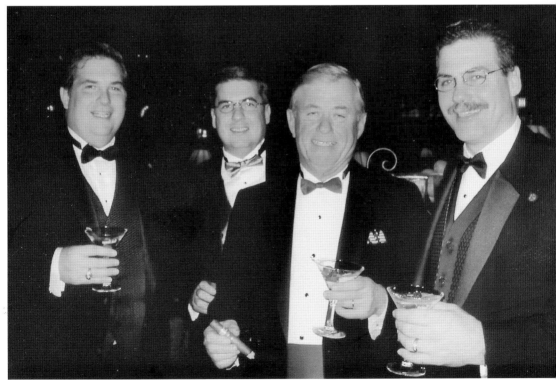

Emma Tousant

Dr. Emma Tousant was a pioneer for local female professionals. She founded the Quincy Business and Professional Women's Club in the 1950s, and from 1961 to 1965, she was chair of the Quincy YMCA board, the first female YMCA board chair in the country. Tousant also chaired the Massachusetts Industrial Accident Board. (Courtesy Quincy Historical Society.)

Nathaniel Hunting

Dr. Hunting was a member of the first medical staff at Quincy City Hospital, which was established in 1890, and one of Quincy's most respected physicians. He helped organize the local branch of the American Red Cross in 1917, and he served on the school committee. His 36 continuous years in elected office is a Quincy record. (Courtesy Quincy Historical Society.)

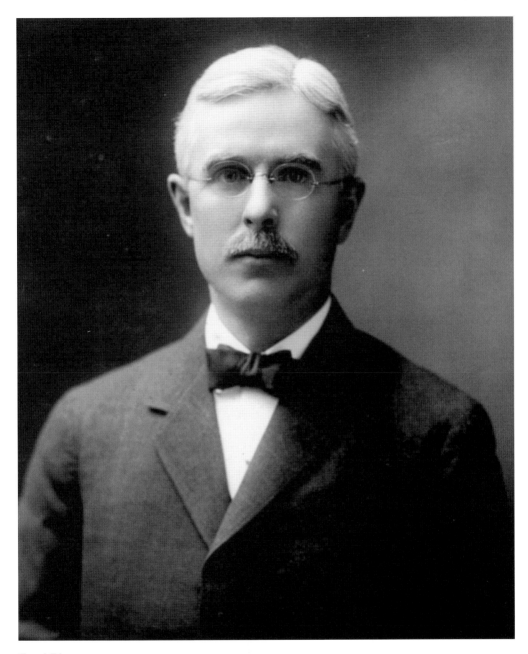

Fred Rice

Fred B. Rice served in several charitable and civic capacities in Quincy, carrying on the good name of his father, William, who gifted the Rice Eventide Nursing Home to the city. Rice served as president of Quincy City Hospital and the National Sailors' Home on Fenno Street, and he was vice president of the historical society. He preserved one of Quincy's great historical buildings when he purchased the home at 181 Adams Street, which was built in 1792 by Capt. Benjamin Beale, after whom Beale Street in Wollaston is named. The home was renamed the Beale-Rice House and was tended to by Rice until his death in 1933. His property was annexed to the Adams National Historic site in 1973. (Courtesy Quincy Historical Society.)

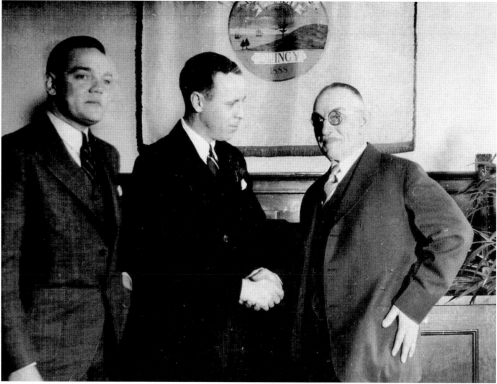

Harry Tirrell

Harry Tirrell (far right, shaking hands with Mayor Thomas Burgin) worked for the city for a remarkable 66 years, the bulk of it as city messenger. As messenger, Tirrell stoked the city hall boiler every morning, opened and distributed mail, and attended every city council meeting. He was also the first exalted ruler of the Quincy Elks, whose West Quincy function hall is named after him. At left is Lawrence J. Curtin, Quincy city councillor. (Courtesy Quincy Historical Society).

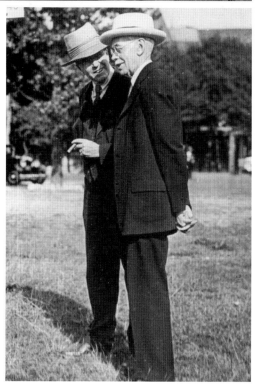

Emery Crane

Emery L. Crane (right, with an unidentified man) was a city institution as its clerk from 1919 until his death in 1941. Exceptionally efficient and an occasional lightning rod, Crane's demeanor harkened to Quincy's old-line Yankee roots as the city underwent great change. He was an uncle of Hollywood actress and Quincy native Ruth Gordon. (Courtesy Quincy Historical Society.)

John Gillis
Known for his combination of charity and wit, Gillis was Quincy's clerk from 1959 to 1992. He was captain of the football team at Quincy High School, from which he graduated in 1942. Gillis went on to work as a Quincy firefighter, and he served as a Marine in World War II, stationed in the South Pacific from 1943 to 1946. He would often let the homeless sleep inside his city hall office on cold nights, and he was generous with his money. Gillis played a significant role in establishing the Democratic Party in Quincy. Few know as much about the city's behind-the-scenes history, and no one tells it as colorfully. Gillis, 91, today serves as a Norfolk County commissioner, a position he has held since 1962. (Courtesy Joe Shea.)

Joseph Shea

Few are as inextricably linked with modern Quincy as Joseph Shea, the city's loquacious and spry clerk. A native of West Quincy, Shea, the son of a nurse and a postal worker, got his city hall start working as executive secretary to Mayor Walter Hannon from 1971 to 1975. Shea also worked in ad sales for the *Patriot Ledger* and at the Massachusetts Bay Transportation Authority. He has been city clerk since 1992, and he became a glue-like figure, holding together dynamic components of city affairs with some of its most observant eyes. At the city's annual St. Patrick's Day roast, Shea assumes the persona of "Shea-zak" (as seen at left, with his wife, Josephine), the cigar-chomping genie of Quincy, with a bottle full of barbs. (Above, courtesy City of Quincy; left, courtesy Joseph Shea.)

CHAPTER THREE

City of Industriousness

A year after seaman Almoran Holmes developed what is thought to be the first derrick for hoisting stone in 1825, carpenter Solomon Willard refined the design in a way that would forever change the stone trade and Quincy.

Looking to tap Quincy's vast expanses of ledge for his iconic Bunker Hill Monument, Willard fortified Holmes's design to handle up to 60 tons of weight. The Granite Railway, one of America's first railways, opened that year, providing a means to transport the quarried stone to Boston. Thus, "Quincy granite," a particularly hard, dark, and sturdy stock, was on its way to becoming known across the country. Some four decades after Willard's innovations, the first machines were developed to polish granite, which up to that point was done laboriously by hand. Industrial-grade quarrying became possible, and Quincy became known as "the Granite City," a place where the industrious could flourish.

Much as Willard sensed opportunity in Quincy's quarries, Thomas Watson sensed possibility when he looked upon farmland he purchased on the Fore River in 1882. The inventor on the other end of Alexander Graham Bell's first telephone call, Watson established a shipbuilding operation on the Fore River that blossomed into a central engine of American wartime manufacturing, as well as a source of employment for tens of thousands. Some of World War II's most critical battleships were launched from the Fore River Shipyard, including the USS Lexington, USS Quincy, and USS Salem, the last all-gun heavy cruiser put into commission. The USS Salem is still docked at the yard and serves as the United States Naval Shipbuilding Museum.

Dunkin' Donuts founder William Rosenberg saw opportunity not in Quincy's undiscovered frontiers but in its existing vitality. Rosenberg owned a food truck company called Industrial Luncheon, and he set up shop in front of the Boston Gear Works factory in North Quincy to capitalize on the hungry workers who emerged every afternoon. The coffee and doughnuts sold best, so Rosenberg sharpened his focus, and in 1950, he opened the very first Dunkin' Donuts on Southern Artery. Rosenberg's story fit an entrepreneurial trend in Quincy in the late 19th and early 20th centuries. John Cashman, a son of Irish immigrants who came to Quincy in his early 20s, founded a construction company in 1874 that would turn into a family empire. In 1907, Russian immigrant Louis Grossman bought an old monument manufacturing plant in West Quincy to expand his junk salvaging business and soon was running a nationally known lumber and building supply company. Howard Johnson took the model behind his first ice cream shop in Wollaston and developed it into orange-roofed "HoJo's" on highway shoulders across America.

From crushed stone to hot coffee, behind all of Quincy's signature industries and brands are industrious men and women who saw possibility and doggedly pursued it.

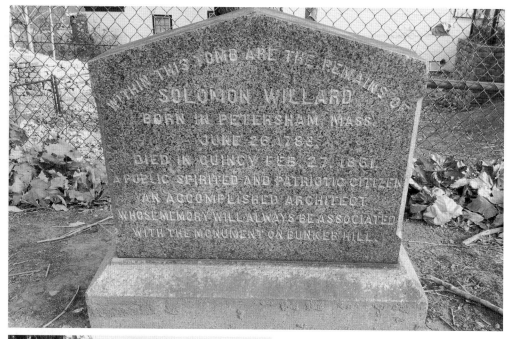

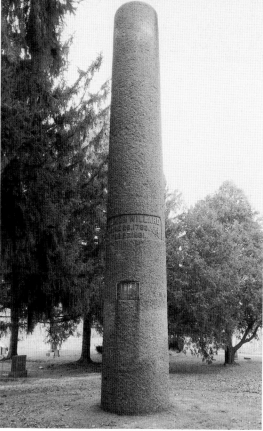

Solomon Willard

Before Solomon Willard, builders hunting for stone strictly trained their sights aboveground, to boulders and ledges poking through the surface. Using Quincy's quarries as his experimentation grounds, Willard pioneered methods to extract granite from beneath the surface in the early 1800s, unlocking a quarrying bonanza. By 1900, there were more than 140 quarrying companies operating in Quincy. A brilliant carpenter and architect, Willard, known as the father of America's granite industry, is credited with designing a range of tools to extract stone on an industrial scale. The Petersham, Massachusetts, native's signature Bunker Hill Monument was completed in 1842, and he died a Quincy resident in 1861. Willard is buried at Hall Cemetery, on Crescent Street in West Quincy, where a towering granite pillar was erected in his honor. (Both, author photographs.)

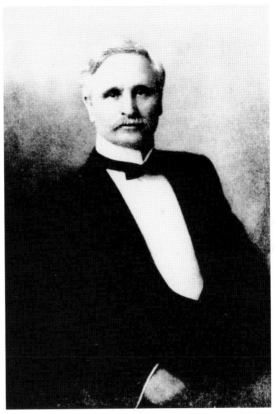

Jonathan Swingle

Where Solomon Willard saw opportunity, Jonathan Samuel Swingle saw an empire. The standard-bearer of Quincy granite, Swingle secured the rights to all the Quincy quarry land he could, and, by 1922, with about 50 acres under his control, he could lay claim to being the biggest individual quarry owner in the world. Swingle came from a family of Ohio coal miners, and he responded to an ad for a job as a bookkeeper for a granite manufacturer in Quincy. In the 1890s, he opened a company with partner Alexander Falconer, a Scottish immigrant who eventually split off to start his own monument company. Swingle continued to buy up land, including the 350-foot-deep Swingle's Quarry (below), the city's last working quarry, which closed in 1963. Swingle's quarries produced especially dark granite; his moniker in the trade was "the Extra Dark Man." (Right, courtesy Quincy Historical Society; below, courtesy Thomas Crane Public Library.)

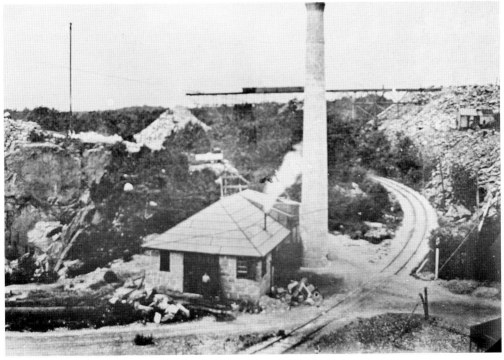

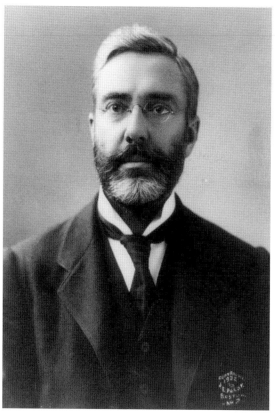

Thomas Watson

Thomas Augustus Watson was already wealthy from his work as an assistant to Alexander Graham Bell when he and a partner started one of America's largest shipyards on the Fore River in 1884. Watson and engineer Frank Wellington initially set out to hawk engines, and they built boats to help sell them. The latter proved more lucrative, though, as the yard won federal government contracts to build warships. Soon, the Fore River Shipyard was a publicly traded entity. Watson resigned from the Fore River Ship & Engine Company in 1904 during a restructuring. Two years prior, he had completed a new iron swing bridge (below) over the river to replace a wooden one, girding the site for a future of heavy, vital industry. (Both, courtesy Library of Congress.)

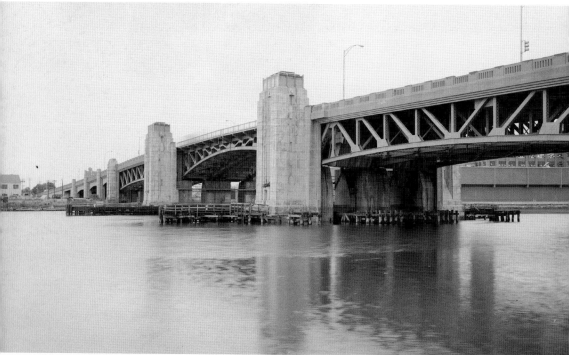

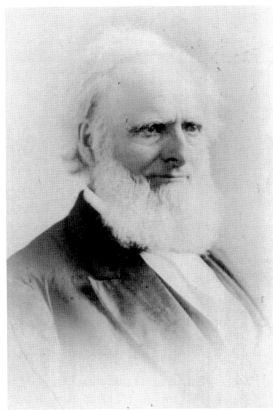

Thomas Crane

Crane was a titan of Quincy's granite industry, beginning as a 15-year-old apprentice in Quincy's quarries and amassing a fortune in stone contracting and real estate in New York. Born on Georges Island in Boston in 1803, Crane moved to Quincy with his family when he was seven. Despite his wealth, Crane was as hearty as New Englanders come. He was known to walk 20 miles to Boston to take in Universalist preachings, and he was praised by Charles Francis Adams Jr. for maintaining "amid all temptations, his New England birthright traits of simplicity, thrift, straightforward honesty, and deep religious feeling." A donation made by Crane's son in his father's honor funded the construction of the Thomas Crane Public Library (below), one of Quincy's architectural gems. Crane died seven years before the library opened, in 1882. (Both, courtesy Thomas Crane Public Library.)

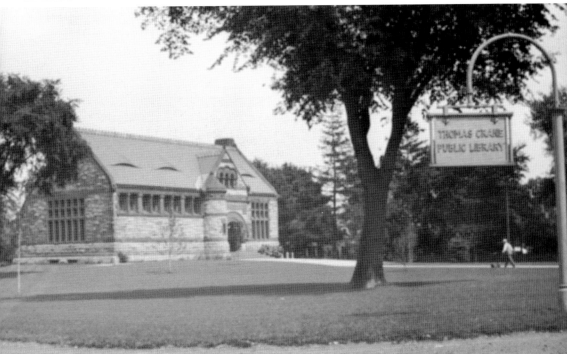

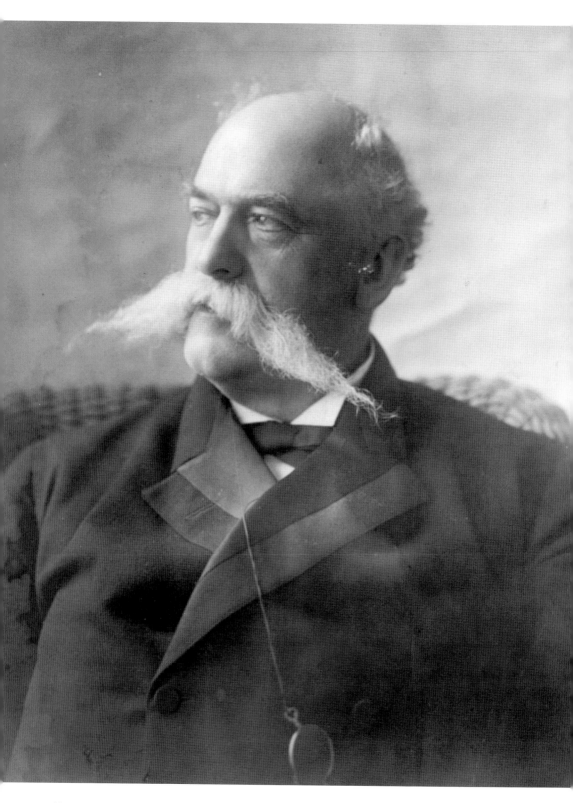

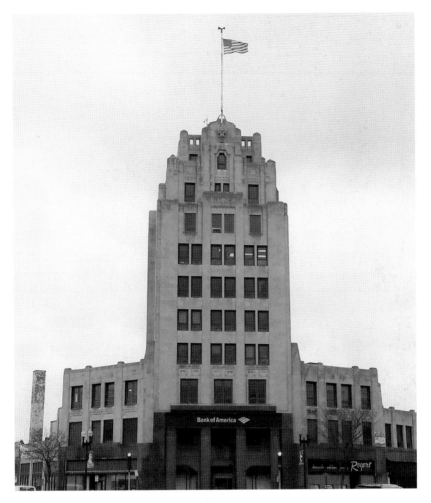

Theophilus King

Quincy's iconic commercial building, the Granite Trust Building in Quincy Center (above), was built by Theophilus King, the city's most prominent businessman and philanthropist in the early 20th century. For 48 years, King was president of the Granite Trust Company, which grew out of the Quincy Stone Bank, Quincy's first commercial bank, which was also said to be the first bank in the United States to offer public stock. In 1929, the art deco Granite Trust Building was constructed using Quincy granite on the original site of Bethany Congregational Church, which King arranged to have rebuilt on its current spot at the corner of Hancock and Spear Streets. King, whose portrait hangs in the Granite Trust Building's bank boardroom, was also president of the Quincy Quarries Company, a holding company for many of the city's quarry owners. King married into the wealthy Baxter family, who owned land at 270 Adams Street, where they built a mansion that is in the National Register of Historic Places. King and his wife, Helen Louise, owned one of the first electric cars in Quincy, which they took out every Sunday for a 50-mile ride, the most the car could muster at one time. A teetotaler and Puritan who advocated for harmony among religious denominations, King was a true philanthropist, distributing $12,600 to 46 churches every year on his birthday. He died in 1935 at age 90. His shared grave with his wife at Mount Wollaston Cemetery is marked by a large granite ball, which includes a touching quote about the couple's affection for each other. The grave reads "Promoted" instead of "Died" next to the date of his passing. A trust King set up for his family still gives a substantial amount of money each year to organizations like the Boy Scouts and the Rotary Club. (Left, courtesy Thomas Crane Public Library; above, author photograph.)

The Grossmans

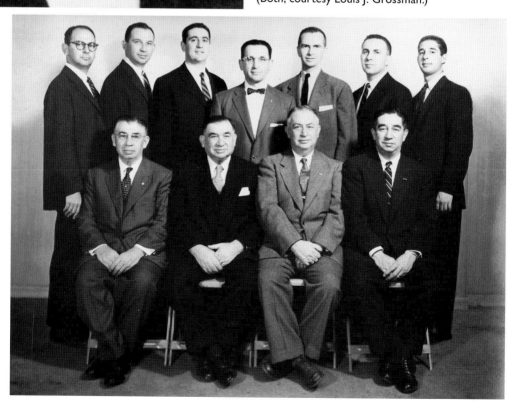

Louis Grossman arrived in Boston from Russia virtually penniless in the late 1880s. One day, he encountered a Russian-speaking peddler who was on his way to Quincy, and Grossman tagged along with him. There, he hawked paper and offered to repair seat covers, and later, he sold salvaged junk he stuffed into a backpack that he wore during grueling walks back and forth to Boston. His family soon joined him in America, and they settled on Bunker Hill Lane in West Quincy. Grossman established the city's first synagogue in a nearby home he later purchased on Water Street. In 1909, he exchanged a load of newspapers for roofing materials with a company in Walpole, Massachusetts, and just like that, the Grossmans were in the lumber and building supplies business. Grossman bought land on Jackson Street and set up shop there. His son Jacob, who left school at age 12 to toss rivets at the Fore River Shipyard, became the company's vice president after his father's 1928 retirement. L. Grossman & Sons expanded to direct consumer sales in the 1940s and 1950s, in some ways an early prototype of a Home Depot–like store. With the slogan "Everything to Build With," Grossmans had 87 retail branches managed by 10 family members at its peak. From left to right are (first row) Jacob, Reuben, Joseph, and Sidney; (second row) John, Morton, Mike, Nissie, Bernard, Everett, and David. The lumber business was sold in 1969, but the family retained control of their real estate, and they have been in the development business ever since. (Both, courtesy Louis J. Grossman.)

Frank Remick

Frank Remick (at right, with his wife, Margaret), the father of Hollywood starlet Lee Remick, had a splendor all his own as proprietor of the fashionable Remick's department store during Quincy Center's "Shopperstown USA" boom period. Known as the "Wide Awake Store," Remick's was opened in a former brick music hall on Hancock Street around 1904 by Frank's father, Alfred, and his uncle, also named Frank. A 1910 fire led to a rebuilding and expansion. Alfred died in 1930, and Frank took over the store (below) in 1935. His daughter Lee, who starred in films like *Anatomy of a Murder* and *Days of Wine and Roses*, would frequently return to Quincy with her children to visit, and crowds would gather in anticipation at Remick's central staircase to catch a glimpse of her. Frank Remick died in 1983 at age 73. (Both, courtesy Quincy Historical Society.)

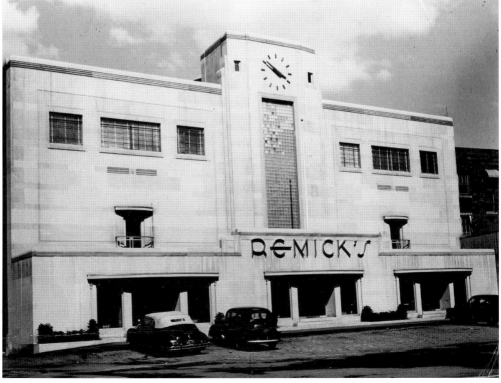

William Rosenberg

William Rosenberg (seated right, with son Robert) opened his first doughnut shop, Open Kettle, on Southern Artery in Quincy in 1948. After two years, he felt he needed to rename it, and he asked employees to tell him what comes to mind when they think of doughnuts. Architect Bernard Healy replied, "What the hell do you do with a doughnut? You pick a chicken, you dunk a doughnut." Thus, Dunkin' Donuts was born. Today, there are over 6,000 Dunkin' stores in 30 countries. Rosenberg sold his first cup of coffee to a factory worker outside of Boston Gear Works in North Quincy in 1946, and his son Robert pushed canteen cars through the former Tubular Rivet factory in Wollaston. Called the "father of franchising," Rosenberg, an electrician by trade, was also an avid philanthropist and horse racing fan. He died in 2002. (Courtesy Dunkin' Donuts.)

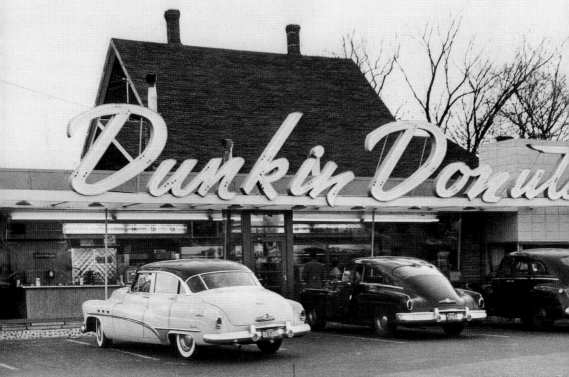

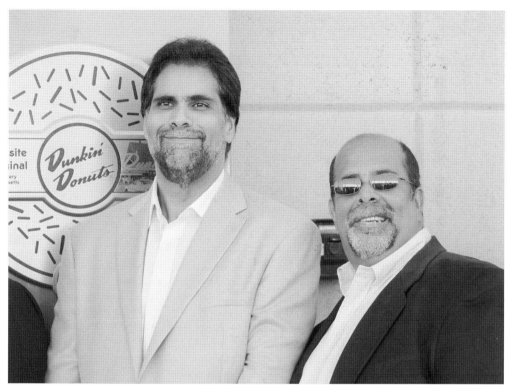

Victor and Octavio Carvalho
Dunkin' Donuts franchisees Victor (left) and Octavio Carvalho (right) have seen to it that the original Dunkin', which their father, Jose, bought in 1979, reflects its history. In 2011, they added a 1950s-style counter and a sign bearing the original Dunkin' logo. (Courtesy Dunkin' Donuts.)

The Original Dunkin'
The original Dunkin' Donuts, at 543 Southern Avenue, was not an instant success. William Rosenberg's onetime business partner and brother-in-law Henry Winokar even suggested closing the shop at one point. Rosenberg soldiered on, renamed the shop Dunkin' Donuts in 1950, greatly expanded his variety of doughnuts, and found the magic recipe. (Courtesy Dunkin' Donuts.)

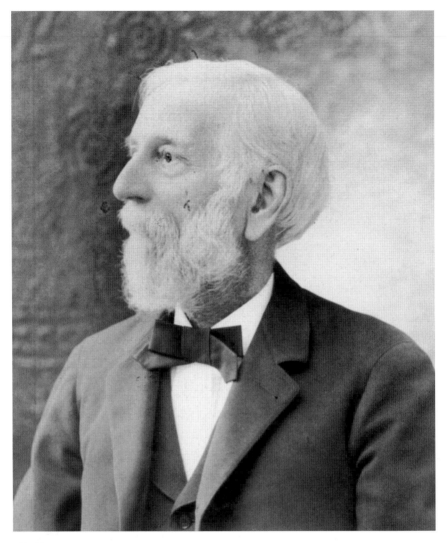

Henry H. Faxon

Henry Hardwick Faxon, born in Quincy in 1823 to Job and Judith B. Hardwick Faxon, was the most noted member of one of the city's oldest families, a lineage that traces to the arrival of Thomas Faxon from England some time before 1647. Faxon made his fortune in a series of enterprises, including a retail grocery and provisions store, grocery wholesale, real estate, and liquor sales. As a state legislator, Faxon would become perhaps the most strident voice in Massachusetts against liquor sales and consumption, preaching temperance and pushing for strict enforcement of drinking laws. Faxon's name endures chiefly due to his generous gifting of land. In 1885, he deeded 26.8 acres to Quincy with the following conditions: the acreage must remain a free public park, it must be called "Faxon Park," and "No intoxicating liquors shall even be sold on said premises under license of any public authority, forever." In 1935, Faxon's son Henry Munroe Faxon, founder and president of Quincy Electric Light & Power Company, gave Quincy an additional 19.6 acres to the south of Faxon Park. In 1940, he gifted 8.2 more acres to the city. Faxon Park and Faxon Field remain Quincy landmarks to this day. Faxon Park was developed in 1938 using funds from the federal Works Progress Administration program, and Faxon Field was recently rehabilitated into a football and track complex next to Quincy High School. Henry H. Faxon died on November 14, 1905. (Courtesy Quincy Historical Society.)

Phyllis Godwin
Phyllis Papani Godwin blazed a trail for female business owners in Quincy, and she is perhaps the most successful businesswoman the city has seen. In 1970, she assumed the helm of Granite City Electric Supply, a company founded in 1922 by her father, Nicholas Papani, who emigrated from Italy at age 16. Virtually alone in the industry as a female executive, Godwin expanded Granite City Electric from its original Quincy location to 28 locations across New England. In 2004, the company struck a deal with the Boston Red Sox, an alliance that made Godwin's company a household name throughout New England. In 1995, Godwin became the first female president of the South Shore Chamber of Commerce, where she launched initiatives to encourage women to get involved in business. (Courtesy South Shore Chamber of Commerce.)

Ernest Montilio

When presidents needed a cake, they called Ernest Montilio (center, with mayors James McIntyre, left, and Arthur Tobin, right). The founder of Montilio's Bakery baked John F. Kennedy's wedding cake, and he would have baked the cake for JFK's 1961 inaugural gala if not for the protestations of the American Bakery and Confectionery Workers' International of America, who complained that Montilio was non-union. "I had to bow out rather than embarrass the President," Montilio told the *Boston Globe* in 1960. Montilio also baked cakes for the inaugurations of Richard Nixon, Ronald Reagan, and George H.W. Bush. Starting in a pizza shop basement in 1947 with his wife, Kay, Montilio grew his business to more than a dozen locations. He baked for Queen Elizabeth during her visit to Boston and for Alfred Hitchcock upon the completion of his 50th film. Montilio was born in Quincy, graduated from Quincy High School, and served in the Army during World War II. He died in 1990 at age 72, leaving the business to his children, who run it today. (Courtesy Quincy Historical Society.)

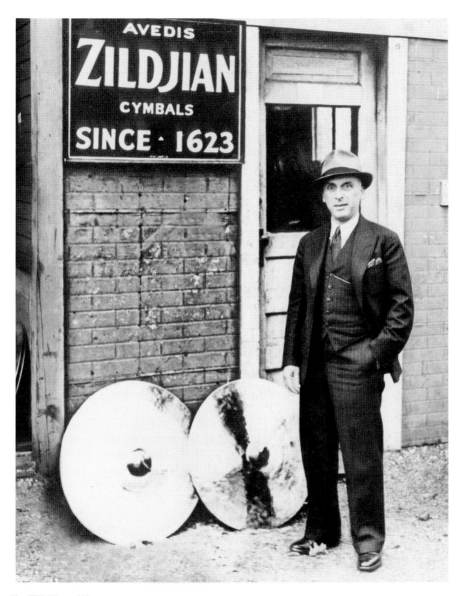

Avedis Zildjian III

In 1927, Avedis Zildjian III received a letter from his uncle informing him that it was time for him to take over the family cymbal-making business, which the family traces back to 1623 in Constantinople. Having moved to Boston 18 years prior and opened a candy shop, Zildjian convinced his family to move the cymbal factory to a dirt-floor building on Fayette Street in North Quincy. His uncle Aram came over as well, and with that, Quincy became forever linked with what has been called America's longest continually operating business. Avedis did everything at the factory, from melting alloys to paying bills to trekking to retailers to hawk his cymbals. A fire in the factory once seared his face; Avedis returned to his desk the same day, wrapped in bandages. Zildjian innovated thinner and multipurpose cymbals, which became an indispensable part of any serious drummer's toolkit. Music legends like Gene Krupa, Chick Webb, and Buddy Rich were photographed outside Zildjian's Quincy factory posing with cymbals. For his innovations, Zildjian was inducted into the Percussive Arts Society Hall of Fame after his death in 1979 at age 90. (Courtesy Avedis Zildjian Company.)

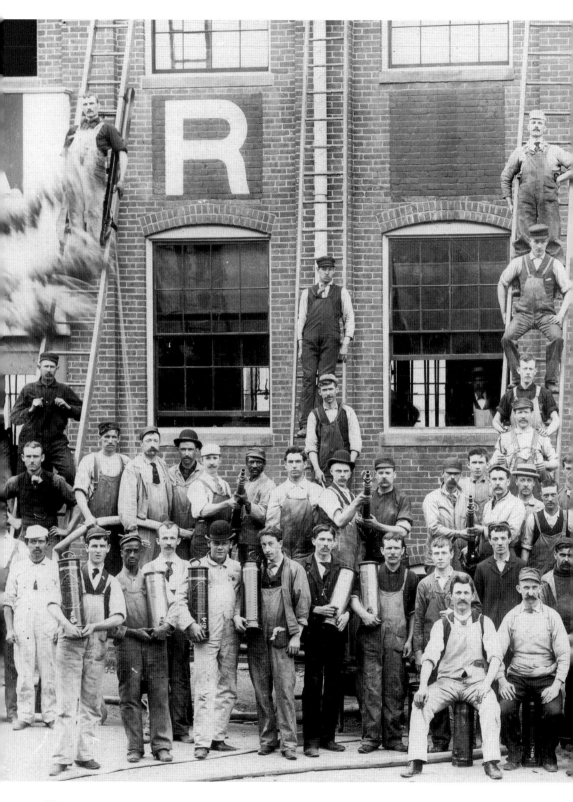

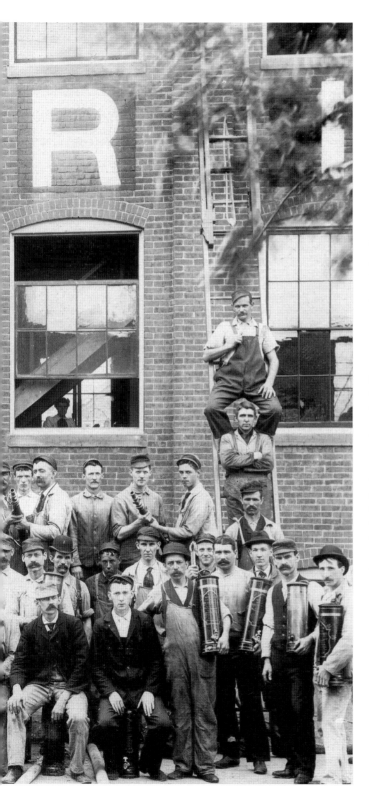

Tubular Rivet and Stud
A Wollaston industrial giant that employed upwards of 1,000 people during World War II, Tubular Rivet and Stud manufactured studs for men's boots and ladies' long gloves. In the 1880s, the company began manufacturing tube-shaped rivets out of a range of materials. Business grew dramatically when it also began making the machines to apply rivets, which were increasingly being used to hold together appliances as well as clothing. Technological advances brought myriad other ways to fasten things, and the factory closed in 1960. Today, the building is the Whittemore Mills condominiums. (Courtesy Quincy Historical Society.)

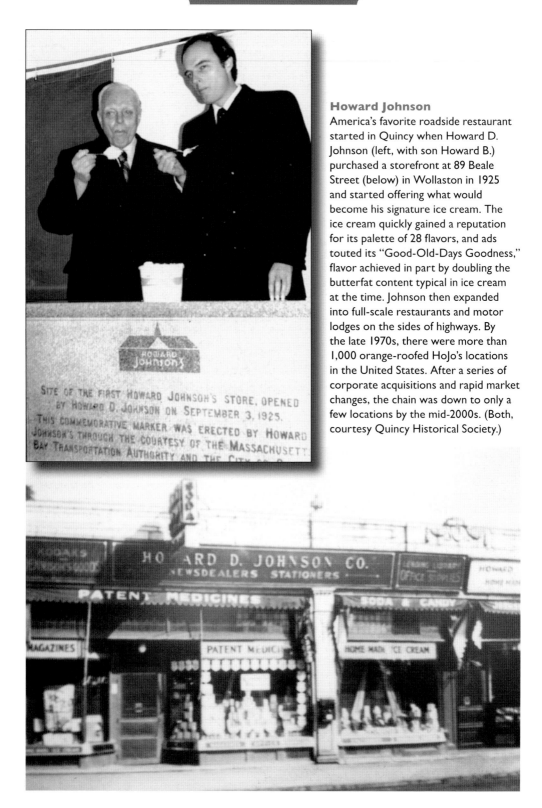

Howard Johnson

America's favorite roadside restaurant started in Quincy when Howard D. Johnson (left, with son Howard B.) purchased a storefront at 89 Beale Street (below) in Wollaston in 1925 and started offering what would become his signature ice cream. The ice cream quickly gained a reputation for its palette of 28 flavors, and ads touted its "Good-Old-Days Goodness," flavor achieved in part by doubling the butterfat content typical in ice cream at the time. Johnson then expanded into full-scale restaurants and motor lodges on the sides of highways. By the late 1970s, there were more than 1,000 orange-roofed HoJo's locations in the United States. After a series of corporate acquisitions and rapid market changes, the chain was down to only a few locations by the mid-2000s. (Both, courtesy Quincy Historical Society.)

SITE OF THE FIRST HOWARD JOHNSON'S STORE, OPENED BY HOWARD D. JOHNSON ON SEPTEMBER 3, 1925. THIS COMMEMORATIVE MARKER WAS ERECTED BY HOWARD JOHNSON'S THROUGH THE COURTESY OF THE MASSACHUSETT BAY TRANSPORTATION AUTHORITY AND THE CITY

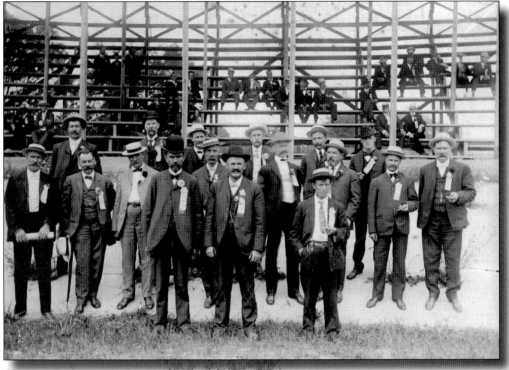

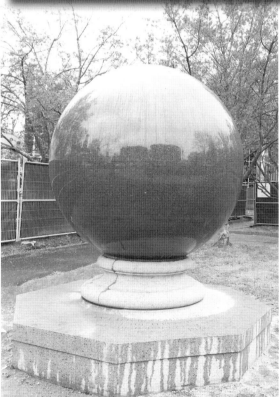

Granite Manufacturers Association

As the granite industry came to define Quincy, its impresarios held great civic and political sway. The Granite Manufacturers Association centralized this power; if one owned a granite-related company, one belonged to it. A lasting symbol of the group's prominence is the 9.5-ton granite ball on display in front of city hall (left), which the association gave to Quincy in 1925 upon its tercentenary. Pictured in the front left is association president John L. Miller, a Nova Scotian who founded the Merry Mount Granite Company. Miller was president of the Stone Cutters' Union in 1878 when a labor clash with owners caused a nine-month quarrying blackout. He was elected mayor of Quincy in 1914 and died in office of an illness. The other men in the image are not identified. (Above, courtesy Quincy Historical Society; left, author photograph.)

Gridley Bryant

Quincy was home to America's first commercial railroad because of engineer Gridley Bryant. Bryant's father died when he was young, and his mother enrolled him as an apprentice with a prominent Boston builder after he showed an aptitude for constructing forts. Bryant commenced building the three-mile Granite Railway in 1826, and he also designed crucial supplements like portable derricks and eight-wheeled railroad cars, inventions for which he claimed to have never received a cent. The railroad provided a way for stone quarried in West Quincy to get to Charlestown, where it was used to build the Bunker Hill Monument. Bryant's name still echoes in West Quincy. The former Bryant School, at 111 Willard Street, today houses offices and is feet from the railway's former incline on Mullin Avenue (below). (Right, courtesy Thomas Crane Public Library; below, courtesy Library of Congress.)

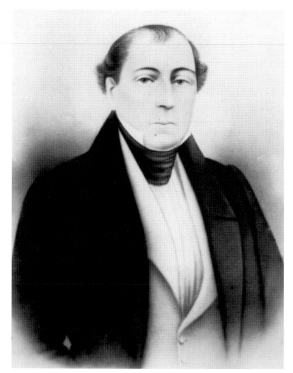

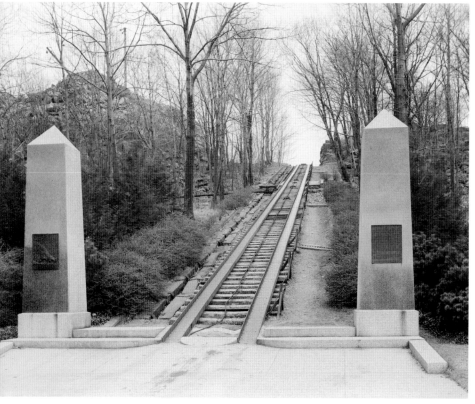

Kilroy

While working at the Quincy shipyard during World War II, John Kilroy habitually scribbled "Kilroy was here" on the rivets, tanks, and other components he had finished inspecting. Servicemen noticed the markings, and the phrase spread across the world after it was combined with a British cartoon character called "Mr. Chad," who was depicted nosing around for supplies that were scant in wartime. The icon appears twice on the World War II Memorial in Washington, DC. (Courtesy Quincy Historical Society.)

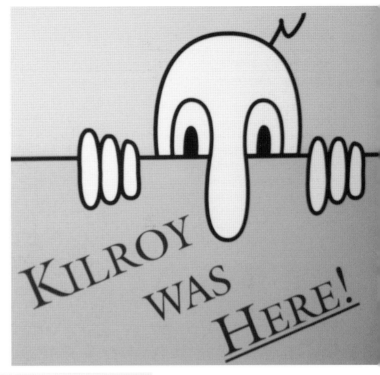

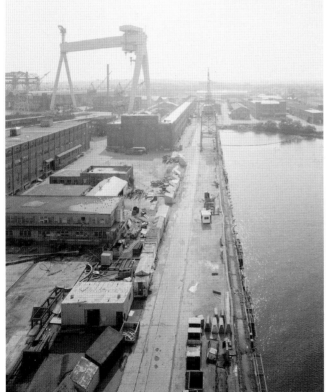

Goliath

A 30-story crane dubbed "Goliath" towered for years over Quincy Point as a beacon of the Fore River Shipyard. The crane (top left corner) was the world's largest when it was positioned in 1974, and it had the name of shipyard owner General Dynamics emblazoned across the top. In 2008, a support leg collapsed during the crane's deconstruction, tragically killing 28-year-old ironworker Robert Harvey, a Quincy native. (Courtesy Library of Congress.)

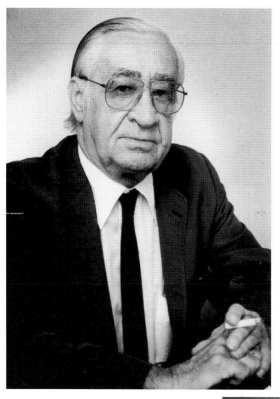

G. Prescott Low

Low was publisher of Quincy's 175-year-old daily newspaper, the *Patriot Ledger*, from 1935 to 1973. Under his leadership, the family-owned publication's circulation grew from 9,000 to 72,000. A somewhat aloof man with a deep knowledge of his industry, Low was a constant presence in the *Ledger*'s old news and composition rooms on Temple Street, with his sleeves rolled up and a cigarette dangling from his lips. (Courtesy Quincy Historical Society.)

Peter O'Connell

Few have shaped Quincy's modern landscape more than Peter O'Connell (center), who, with his brother William, developed some of the largest mixed-use projects in the city. The sons of a milkman and one-time mayoral candidate, the O'Connells transformed a defunct Squantum air station into a thriving luxury neighborhood called Marina Bay and filled quarries in West Quincy to create Granite Links Golf Course. At left is Thomas Galvin, president of the South Shore Chamber of Commerce, and at right is Arthur Murphy, a Quincy attorney. (Courtesy Thomas Galvin.)

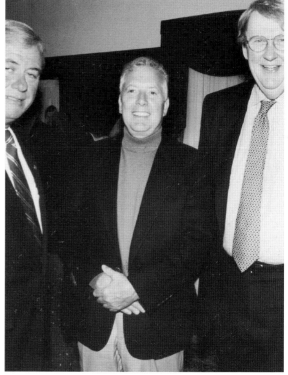

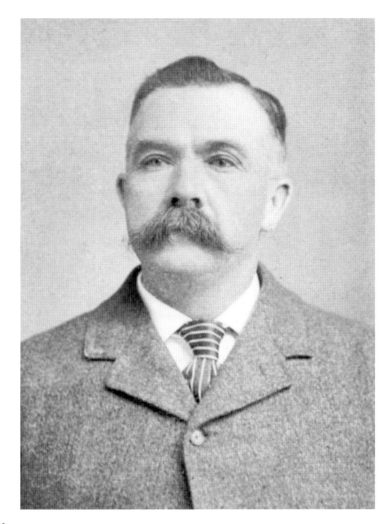

John Cashman

John Cashman was one the most active and energetic businessmen in Quincy in the late 19th century and the first in a long line of enterprising Cashmans to thrive in the city. Born in Inishcarra, County Cork, Ireland, in 1849, Cashman came to America when he was eight months old. His parents, James Cashman and Catherine Long, left their famine-ravaged homeland and started a new life in Massachusetts. In his early 20s, John came to Quincy, where he started his own teaming business in 1874. He married Hannah Falvey of Quincy and had 12 children. Business flourished, and by 1893, he employed 40 people and was accepting contracts for teaming, excavating, road building, and stonework. His residence, stables, and storehouse were located at the Cross Street railroad crossing in West Quincy. In the late 1890s, Cashman turned his attention to bridge building, constructing spans for the Old Colony and New Haven Railroads. He also built deep-sea walls up and down the Massachusetts coast and was involved in the construction of the Pilgrim Monument in Provincetown. Additionally, he built the local waterworks and contributed the granite used in the construction of his parish church, St. Mary's, in West Quincy. In addition to his contracting work, he served as road commissioner for the City of Quincy, president of the Quincy Electric Light & Power Company, and superintendent of the Quincy Quarries. He owned a large quarry in West Quincy, and his dredging company, Bay State Dredging, Ltd., was responsible for dredging waterways from Ipswich to Cotuit. When he died in 1913, Cashman was considered one of the best-known contractors and bridge builders in Massachusetts. (Courtesy Jay Cashman, Inc.)

William Cashman

William Cashman moved to Quincy at age 29 to live and work with his brother John in West Quincy, and he soon became the overseer for his brother's company. In 1891, while working on a job in Scituate, he met his future wife, Mary F. Murphy, and the newlyweds settled into a home William built at 117 Cross Street. William eventually went into business for himself, selling coal and wood in the winter and ice in the summer. The William Cashman & Sons yard was situated at the corner of Furnace and Willard Streets in West Quincy, and it was successful in an era when coal was the primary fuel for heating homes. William was also contracted to build the sewer systems in Milton and Hyde Park. He died in 1918 at age 58. (Courtesy Jay Cashman, Inc.)

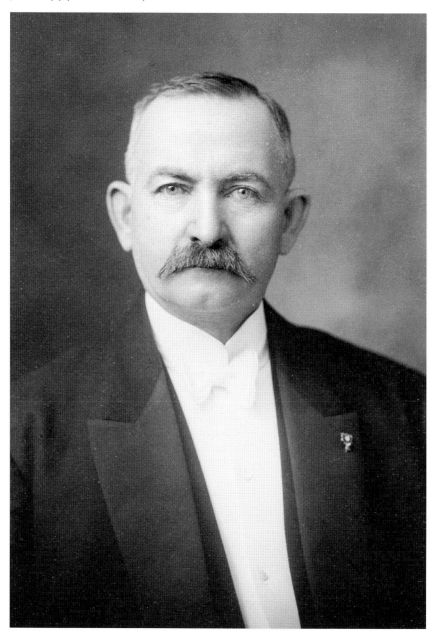

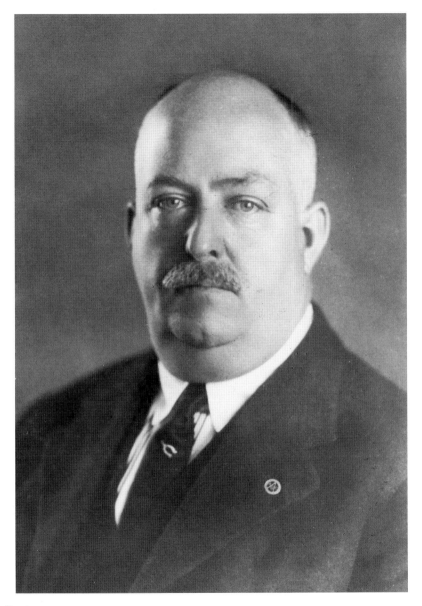

James Cashman

The son of John Cashman, James Eugene Cashman was born in Quincy in 1876 and spent his first 31 years learning the contracting business from his father. When his father won a contract to repair the Burlington breakwater in 1903, James was sent to Vermont to oversee the job, and by 1905, he was winning contracts under his own name. He settled in Burlington, Vermont, with his wife, Ada James, and their five children. He constructed many of Burlington's principal buildings and bridges, including city hall, Memorial Auditorium, and the Winooski Bridge. After his father died, James became general manager of Bay State Dredging & Contracting, overseeing important projects like the Bellevue Hill water tower in West Roxbury, the high-level sewers at Needham, the Metropolitan Park Boulevard in Quincy, and dredging for the Boston Army Supply Base. James was New England director for the Associated General Contractors of America, an organization which instituted an annual award in his name. At the time of his death in 1931, he owned the largest contracting business in Vermont. (Courtesy Jay Cashman, Inc.)

Jay Cashman

In the spirit of entrepreneurship displayed by three generations before him, Jay Cashman built a multinational company, headquartered in Quincy, that is a leader in the fields of heavy civil and marine construction, dredging, demolition, and wind power generation. Jay grew up in Quincy and got his start taking on small residential construction jobs in the city while a teenager. Jay Cashman, Inc., has completed some of the most challenging and significant construction projects in North America, such as the 2001 Fort Point Channel crossing of the Central Artery/Tunnel project, the largest and deepest soil-mixing project ever undertaken in the United States. Cashman was hired in 2004 to complete 10 key "Big Dig" highway projects after a major contractor went bankrupt. Cashman's company's other projects include the cleanup of Boston Harbor and the Hudson River for General Electric, the largest environmental dredging project in American history. Cashman also owns a portion of the Fore River Shipyard, and his company's work led to the 2007 reopening of the 18-mile Greenbush commuter rail line connecting South Shore communities to Boston. Cashman has made numerous contributions to Quincy, such as planting 30,000 trees, rebuilding the Souther Tide Mill, gifting a historic Coast Guard boathouse and pier to the city, and volunteering with the public schools' Junior Achievement program. Cashman is also a longtime supporter and major sponsor of Quincy charities, such as DOVE (Domestic Violence Ended) and Father Bill's Place emergency homeless shelter. (Courtesy Jay Cashman, Inc.)

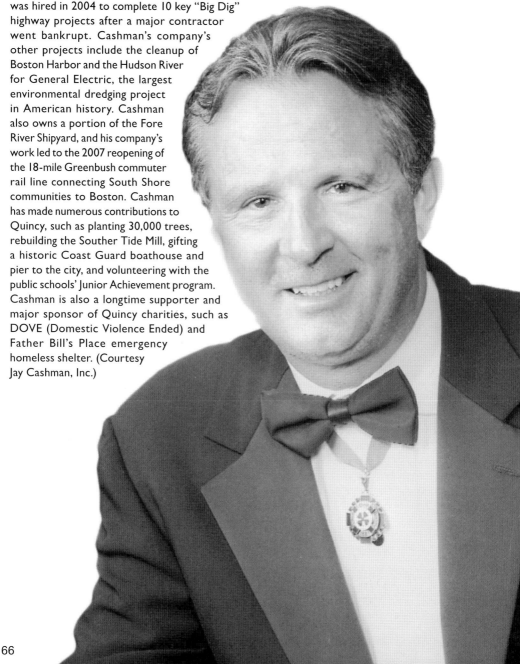

CHAPTER FOUR

City of Education

On April 20, 1900, Col. Francis Wayland Parker, Quincy's first superintendent of schools, stood before a crowd in the famed Stone Temple to discuss his system of educating schoolchildren, which had swept the nation when he began his tenure 25 years earlier. "In school the child has too often a separate stream of thought, or a stagnant pool, totally separate from his real life," Parker told the crowd. "A child should have one life, wholesome and complete, and the home life and the school life should each supplement the other."

Dubbed "the Quincy Method," Parker's educational system stressed each child's individuality and making lessons resonant with them by tapping into their desires, hopes, fears, griefs, and joys. Just as patriotism, quarrying, and shipbuilding spread Quincy's name across the land, Parker's public education innovations also brought prestige and identity to the city. Parker began his work on April 20, 1875, and was given free reign by Quincy's school committee to experiment with ways of bringing together students from different classes, races, and genders. His method sought to hone students' powers of observation as much as their powers of comprehension, and he advocated physical activity as a way for students to manifest what they were learning. The approach won plaudits nationwide and drew interested experts, teachers, and journalists to Quincy to observe classrooms. Parker was soon tapped to lead the Boston and Chicago schools and regaled many an audience with his sharp insights into how a staid education system could and should be transformed.

Still today, Quincy's education leaders look to Parker for inspiration and guidance. Longtime superintendent Eugene Creedon was known as a Parker wonk, seeing his life's work as carrying on the principles his predecessor espoused. The principles of student-centered learning live on in Quincy, which hosts the headquarters of the Nellie Mae Foundation, the largest charity in New England focused solely on education. The city venerates educators who show a lasting commitment to its children, naming schools and auditoriums after bygone educators. Quincy can also lay claim to a number of influential turn-of-the-20th-century thinkers who made underappreciated contributions to American intellectual life. While it has changed substantially over the decades, the Quincy Method lives on.

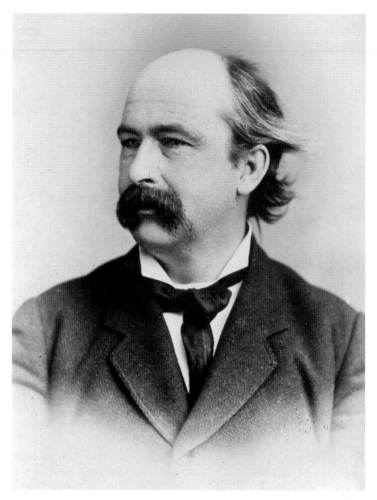

Francis W. Parker

Credited with innovating the Quincy Method of student-centered teaching as the city's first school superintendent, Colonel Parker once famously denied such a method existed, because it suggested a static way of teaching that could not be amended or reshaped. "There never was a Quincy method or a Quincy system, unless we agree to call the Quincy method a spirit of study, and the Quincy system one of everlasting change," Parker said in 1900, a quarter-century after he was appointed. In 1875, the Quincy School Committee, chaired by John Quincy Adams II, was authorized to hire a superintendent of schools. Committee member James H. Slade had recently made the acquaintance of Parker, who had just returned from a trip to Germany to study cutting-edge methods of instruction for elementary students. Parker has been called the "father of progressive education" for his frameworks, which shifted away from memorization and toward personalization. It was said he came into schools that operated as machines and left them as living organisms. Parker once famously asked a Houghs Neck student what a peninsula was and received a textbook explanation in response. But the student didn't grasp that she was, at that moment, on a peninsula, illustrating the difference he sought to highlight between memorizing and understanding. While Parker's system had its detractors, aptitude tests of Quincy students under his regime stacked up quite favorably. After five transformative years in Quincy, Parker was hired to run the Boston and Chicago school systems. He died in 1902 at age 64, espousing until the end that ingraining in a child the "spirit of study" is the essential element to his or her successful education. Parker Elementary School in North Quincy is named in his honor. (Courtesy Thomas Crane Public Library.)

William Everett
Everett was the longtime face of the Adams Academy, the boys' school built with money bequeathed to Quincy by John Adams. The son of former Massachusetts governor Edward Everett, William Everett was the longest-serving of the academy's three headmasters, occupying the post from 1878 to 1893 and from 1897 to 1908, the academy's final year. (Courtesy Quincy Historical Society.)

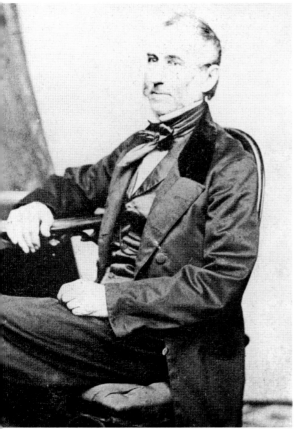

Ebenezer Woodward
A short time after John Adams gifted funds to build a boys' school in Quincy, his longtime personal physician and cousin Dr. Ebenezer Woodward dedicated his estate for the construction of a school for girls. A quarter-century after Woodward died, the Woodward School for Girls opened across the street from the Adams Academy on Hancock Street. It had 76 students and seven teachers when it opened in 1894, and it now welcomes local and international students. (Courtesy Thomas Crane Public Library.)

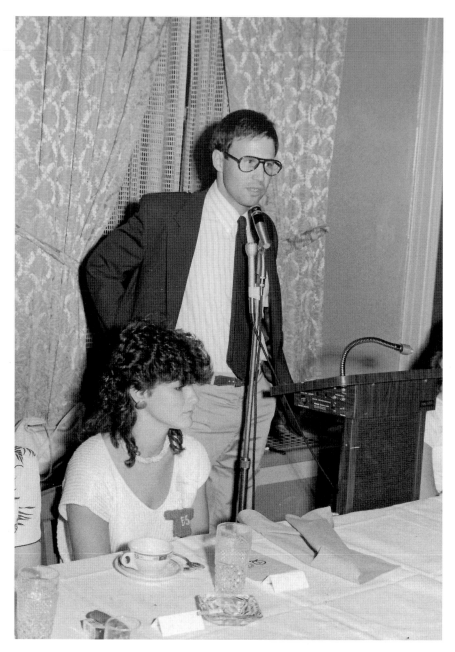

Carmen Mariano

A former assistant superintendent of schools, Carmen Mariano was known as a workaholic and a dynamic educator who coached the Quincy High School wrestling team with as much passion as he administered district affairs. A Quincy Point native, Mariano held about every education job in Quincy, from classroom teacher to principal of Quincy High School. Popular with teachers and students alike, Mariano was known for his motivational speeches, his hands-on teaching style, and for being a reliable presence at virtually every function where Quincy's colors were flown. Even retirement could not quell him; he now serves as principal of Archbishop Williams High School in nearby Braintree. (Courtesy Quincy School Department.)

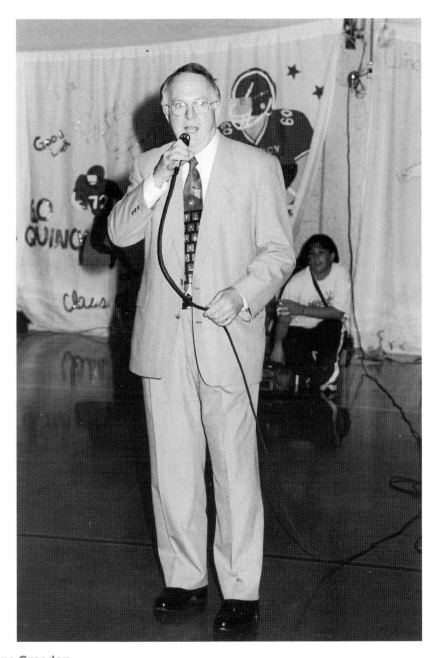

Eugene Creedon

Longtime Quincy schools superintendent Eugene Creedon was part of a family that made immeasurable contributions to their native city's education system. A humble yet brilliant educator, Creedon could be found working directly with grammar school students even as he rose to superintendent. His 36-year career in education ended when he retired in 2001. Creedon implemented the district's popular student voting program, in which pupils vote in their own mock election for US president as a civics lesson. He is also credited with initiating the building program that spawned a new, state-of-the-art Quincy High School. Creedon's brother Lawrence was also a longtime Quincy superintendent, and his wife and three daughters went on to teach in Quincy schools. (Courtesy Quincy School Department.)

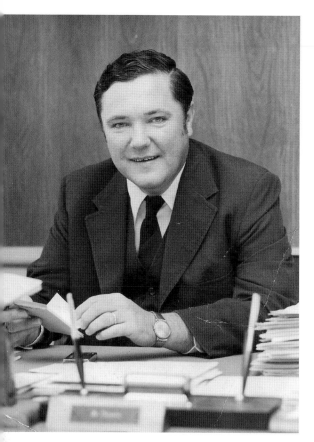

Peter Chrisom Sr.
A former Marine tank commander, Peter Chrisom brought a swagger and command to his 26 years as principal of North Quincy High School, his alma mater. A history teacher with a taste for cigars, Chrisom was a consistent presence in the school's hallways, never hesitating to wade into the fray to keep order. Chrisom launched arts enrichment and school pride initiatives, and the district dedicated North Quincy High's auditorium to him after his death in 2011. (Courtesy Susan deVarennes.)

Reay Sterling
The namesake of Sterling Middle School, Reay Sterling was a teacher and administrator in Quincy schools from 1927 until his untimely death in 1963 at age 58. A native of Morris Run, Pennsylvania, Sterling attended Boston University and began his teaching career at South Junior High School, the original name of the school that was later named after him. (Courtesy Sterling Middle School.)

Frank Santoro

High school basketball standout Frank Santoro often towered over his students at Quincy High School, but he knew how to get on their wavelength. The affable Quincy native was the school's principal from 2004 to 2013 and a presence at every school event, occasionally even showing up at games after his retirement. Santoro championed an interdisciplinary arts curriculum that, somehow, convinced football players to give chorus a try. He also founded the North Quincy High School Basketball Hall of Fame. (Courtesy Frank Santoro.)

Robert Sylvia

The iconic 45-year coach of Quincy High School's boys' hockey team, "Syl" was also a guitarist and folk singer. Plain-dressed and plain-spoken, Sylvia forged lasting bonds with generations of aspiring Bobby Orrs, and he was known to report to school around 5:00 a.m. to jog the entire property before starting his day. (Courtesy Quincy School Department.)

William Sullivan

Coach William "Sully" Sullivan may have been the closest thing Quincy had to Vince Lombardi. A football star at Quincy High School from 1928 to 1930, Sullivan returned as head coach in 1952 and coached until 1959. His Thanksgiving Day clashes with rival North Quincy High School, coached by Jack Donahue, were the biggest show in town, packing up to 25,000 into Veterans Stadium. A Navy reservist, Sullivan was the only Quincy High School coach in five decades to lead the Presidents to five consecutive Thanksgiving Day victories, and he had the first retired number (No. 15) in school history. A dapper dresser with a gift for fiery speeches, Sullivan continued to address players into his 70s at team dinners. He died in 2003 at age 90. (Courtesy Quincy School Department.)

Jack Raymer
Raymer, whose band regularly entertains at various area clubs, was as adept on the mic as he was on the sidelines as coach of Quincy High School's football team. He retired from Quincy schools in 2012 after coaching and serving in a host of administrative capacities. Along with friends John Mahoney and Ken McPhee, Raymer founded the Quincy–North Quincy Football Hall of Fame in 1983. (Courtesy Quincy School Department.)

Charles Bernazzani
Quincy schools were deeply shaken by the loss of Bernazzani, the fun-loving principal of the former Furnace Brook School, who suffered a medical episode while making a presentation during a 1987 school committee meeting and later died at Quincy Hospital. He was 58. The Furnace Brook School, of which he had been principal since 1974, was renamed the Bernazzani School in his honor. (Courtesy Bernazzani Elementary School.)

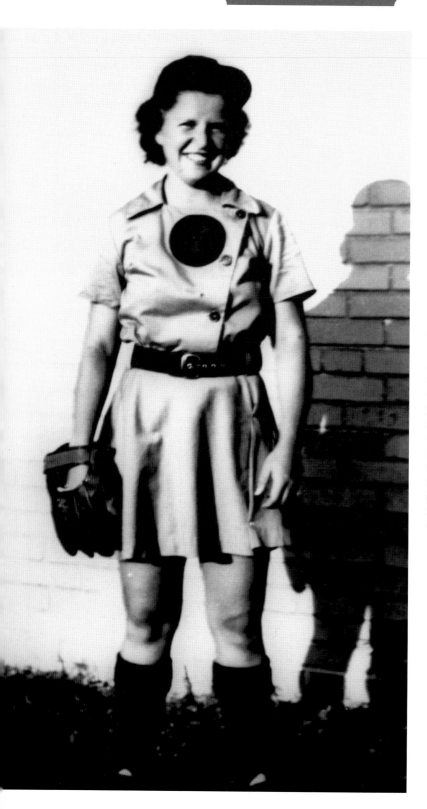

Mary Pratt

Generations of Quincy students simply knew her as their gym teacher. But, during World War II, Mary Pratt was a noted pitcher in the All-American Girls Professional Baseball League, which was immortalized in the 1992 film *A League of Their Own*. Pratt's father was a Quincy native, and he moved his family to the city in 1932 to take a job for Bethlehem Steel Corporation at the Quincy Shipyard. Pratt pitched for the Rockford Peaches and the Kenosha Comets, throwing a no-hitter in her banner 1944 season. After baseball, she worked as a physical education teacher in Quincy for 42 years, starting in 1946. She also coached for the city's recreation league. Now 95, Pratt is still a presence in the city, speaking at events about her time in baseball and attending functions for retired teachers. (Courtesy Quincy Historical Society.)

Richard DeCristofaro

The hands-on superintendent of Quincy schools, Richard DeCristofaro comes from a family with a long history of service to the city. The son of Quincy Point pillars Ted and Betty DeCristofaro, Richard coached basketball camp and was a teacher in the district. He knows the school system as intimately as anyone, from the boiler rooms to the principals' offices. (Courtesy Larry Norton.)

Lloyd Hill

Hill embodied Quincy High School as its principal from 1978 to 1998. An All-American football player at Brown University, he was a career Quincy teacher and coached football at North Quincy High. Powerful yet mild-mannered, players would spot Hill in a guard shack at a North Quincy factory he worked security for, studying for his law degree. The Quincy High School performing arts center is named after him. His son Rich Hill is a Major League Baseball pitcher. (Courtesy Quincy School Department.)

William Parsons Lunt

The Reverend William Lunt was perhaps the most celebrated pastor to preside over the United First Parish Church. Known for his orations and writings, Lunt delivered a memorable discourse at the interment of John Quincy Adams in 1848. He is tied up in the story of the Christmas carol "It Came upon a Midnight Clear." The carol's author, William Sears, said he composed it at the request of Lunt, who was seeking a festive song for children to sing at Sunday school. (Courtesy Thomas Crane Public Library.)

Edward Mann

As a 16-year-old in 1925, Mann came from Vermont to study at Eastern Nazarene College in Wollaston. He never left the institution. Mann joined the faculty after earning a math degree, and he became president of the Christian liberal arts college in 1948. During his 22-year tenure, Mann bridged the institution and the broader Quincy community and greatly expanded the school's footprint. He died in 2005 at age 96. (Courtesy Quincy Historical Society.)

Mary Parker Follett
Follett, a Quincy native, was a dynamic lecturer on management and organizational theory in the 1920s and 1930s. A compendium of her speeches included in the 1942 book *Dynamic Administration* helped cement her reputation across the country. Follett is credited with playing a key role in developing management cornerstone concepts in business and government, including an emphasis on process, citizenship, diversity, and equitable solutions. "We must remember that most people are not for or against anything; the first object of getting people together is to make them respond somehow, to overcome inertia," Follett wrote in her 1918 book *The New State: Group Organization, the Solution of Popular Government*. Follett is generally considered to be underappreciated historically, but she has a passionate following who see her as a prophet in her field. (Courtesy Quincy Historical Society.)

Allan Yacubian

In a North Quincy High School health class in 1957, student Allan Yacubian was asked by classmate and talented artist Peter Fredericksen to remove his glasses. Fredericksen began to draw Yacubian's face, and by the time he was done, North Quincy High had its new mascot: a hammer-wielding, determined-looking icon for the Red Raiders named "Yakoo," an iteration of Yacubian's name. A stir in the 1990s led to debate about whether the logo was insensitive to Native Americans; after a four-year review, the US Department of Education determined the mascot did not constitute a civil rights violation. Yakoo was hardly Yacubian's only contribution to Quincy schools. The retired dentist has long been one of the school's most generous benefactors, making low-key donations and occasionally surprising classes with Twinkies and ice cream at lunchtime. (Both, courtesy North Quincy High School.)

CHAPTER FIVE

City of Politics

Long a city of Boston expats, Quincy shares the same politics-as-sport culture as the hub city to its north. Election results are voraciously studied by insiders and outsiders alike, observers handicap who the political stars of the future are going to be, and there is a constant debate about the ramifications of the day's news for office holders. Yet, for all its robustness, Quincy's political scene is intensely local. For the Quincy official, navigating issues like snowplowing and disputes between neighbors can be just as delicate as staking out positions on economic and social issues.

While intensely tribal, Quincy's political class respects anyone who can get elected and win over the city's demanding electorate. The late Clifford Marshall, former city councillor, state representative, and 21-year sheriff of Norfolk County, is still vaunted for having never lost an election. James Sheets, a native of Pennsylvania coal country who came to Quincy to attend Eastern Nazarene College, won the allegiance of locals by fighting in and winning tough elections. When longtime city and county official William Delahunt was elected to the US Congress in 1997, Quincy's political class did not hesitate to draw a historical link between Delahunt and the last native son to represent the city in Washington, John Quincy Adams.

Political seats in Quincy have long been coveted, often for an eclectic set of reasons. Wealthy businessman Perley Barbour, the mayor from 1925 to 1926, famously sought office for the simple, expressed purpose of being the face of the city during its tercentenary celebration and the organizer of the associated pomp. It would not be long before that type of pretense no longer flew in Quincy. Just 30 years after Barbour, Mayor Amelio Della Chiesa had to constantly fend off criticisms that he was nothing but a "ribbon cutting" mayor, the very definition of Barbour's administration.

As important as granite and shipbuilding are to the story of Quincy, the people who have played in the city's political arena give Quincy its personality and texture. In Quincy, there is no real difference between history and political history.

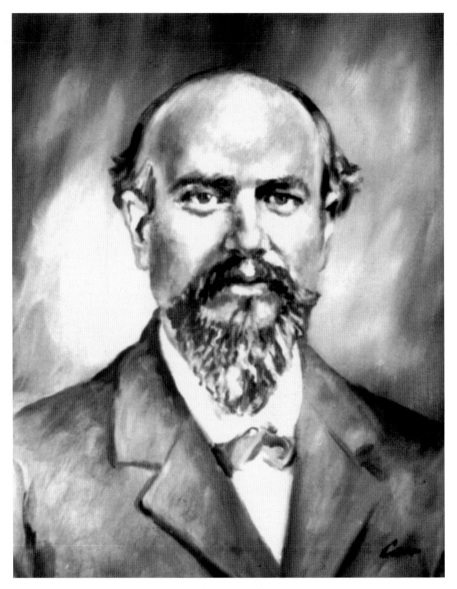

Charles H. Porter

Porter was Quincy's first mayor, elected in 1888 after the then town ratified a charter to become a city. The charter vote came after a heated campaign that pitted many of the town's most powerful and influential residents against each other, with opponents arguing it placed too much power in the chief executive's hands and structured government too much like a corporation. Still, Porter's election was received favorably. In an editorial published after Porter was elected, the *Patriot Ledger* deemed the Republican "an honest, upright businessman and neighbor" and declared that residents can "safely trust him to set the wheels of the new city government in motion and to establish a precedent which his successors in office will be glad to continue." Porter served in the Union army, worked in insurance, and was a board member at the venerable Quincy Mutual Fire Insurance Co. He took the helm of the city of 12,000 residents on January 7, 1889. The new city charter afforded him great power to hire and fire municipal officers, and his first city budget was $334,514. Quincy's original charter called for one-year mayoral terms, and Porter won two before retiring the seat. (Courtesy Thomas Crane Public Library.)

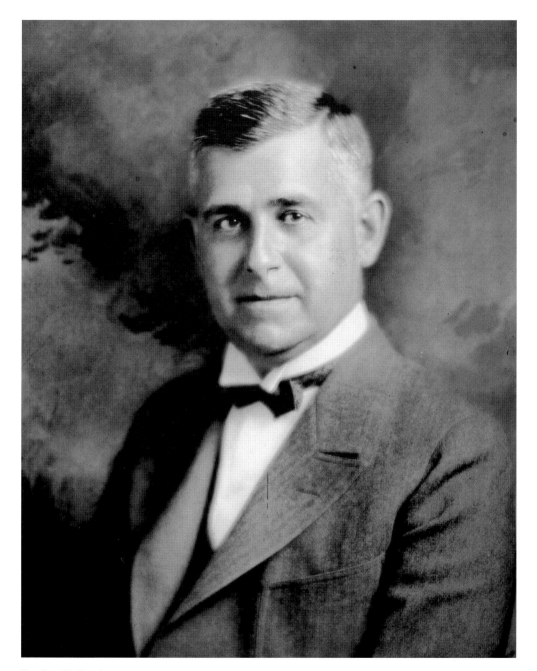

Perley E. Barbour
Around 1924, a group of Quincy politicians gathered in a private home for a discussion and spirits. There was buzz around the upcoming mayoral election, and all eyes were on city councillor Charles Ross to make a bid. However, fellow councillor Perley Barbour, a wealthy businessman who owned a patent for a particular manner of shoe welting, announced that he fancied being mayor upon the city's 300th anniversary. Barbour pledged to Ross that if Ross stepped aside, he would only serve one term and then retire. Barbour kept his word, after presenting a rousing, weeklong celebration rife with song, elaborate pageants, and a 182-float parade. (Courtesy Quincy Historical Society.)

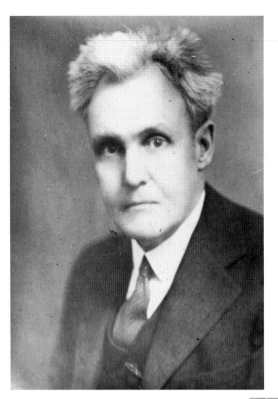

Thomas J. McGrath
The mayoral succession plan envisioned by Perley Barbour and Charles Ross did not factor in a wildcard named Thomas McGrath. A printer who dropped out of school in the eighth grade to support his widowed mother, McGrath developed a command of city finances as a city councillor and defeated Ross in the 1926 and 1928 mayoral elections. (Courtesy Thomas Crane Public Library.)

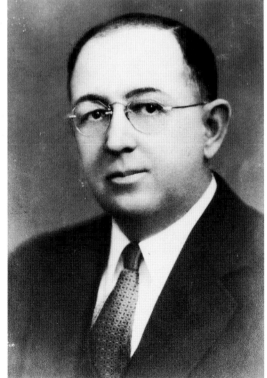

Charles A. Ross
Ross finally secured the mayor's office in 1932, and he helped guide the city through the Great Depression. Born in Scotland and a piano maker by trade, Ross saw his first tenure end abruptly. He was found guilty of filing false campaign finance statements in a 1935 trial that stripped him of the mayoralty, the only time that has happened in Quincy. The electorate did not see the politically tinged scandal as a fatal blow, however, as Ross won back in the mayor's chair in 1942. (Courtesy Thomas Crane Public Library.)

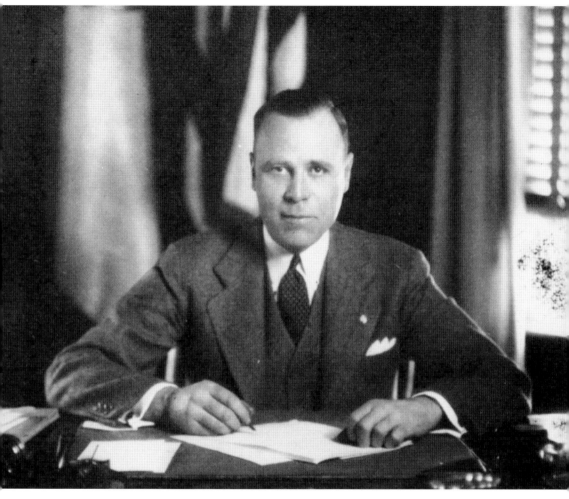

Thomas S. Burgin
Burgin stepped into the mayor's office after Charles Ross was ousted and led Quincy through trying times. A hurricane in 1938 caused extensive damage, and the attack on Pearl Harbor in 1941 sparked a false, panic-inducing report that enemy planes were headed toward Quincy. The son of a bank executive who founded the city's Neighborhood Club, Thomas Burgin founded an insurance agency that still operates today, Burgin Platner Hurley. Burgin was pegged as a future political force upon his first election at age 22. The youngest mayor in Quincy history, he was the first to run unopposed, and he served four terms before taking a commission with the Navy. Burgin oversaw a range of Works Progress Administration projects that kept Quincy humming during World War II. Always dressed to the nines, Burgin remained a dignified presence in the city after leaving office, and he returned in the 1950s to win election to the city council and state legislature. Burgin Parkway, one of Quincy's main thoroughfares, was named in his honor in 1985. He died of cancer the next year. (Courtesy Quincy Historical Society.)

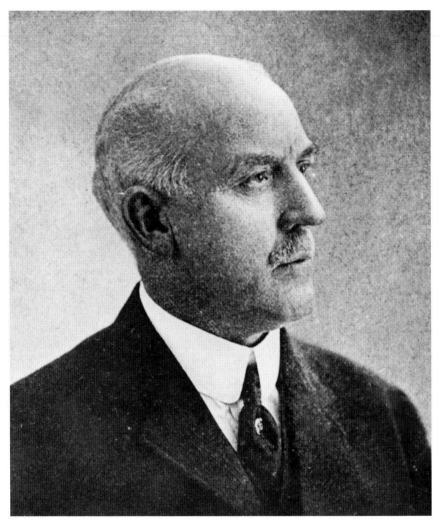

William T. Shea

Shea was Quincy's first Irish American mayor. He was also a Democrat decades before that described most of the city's political makeup. He was elected to four one-year terms from 1908 through 1911. Born in Quincy as the first of eight children of Irish immigrants, Shea was educated in Quincy and joined his father's granite contracting firm after graduating high school. He learned every feature of the business, from quarrying stone to cutting, lettering, and setting it in place. After his father died in 1889, Shea assumed leadership of William Shea & Sons, and he gradually shifted the firm's focus to street building, sewer construction, paving, excavating, and general contracting. In 1896, Shea built the foundations of the Gridley Bryant and Massachusetts Fields Schools in Quincy. When Quincy became a city in 1888, Shea, a progressive, was elected a member of the first city council. For 12 years, he was a member of the Democratic state committee and was sent as a delegate to the national conventions. Shea was famous for once saying, "I believe playgrounds should be flooded for skating," and Shea Rink in West Quincy was dedicated to him in the 1950s. Shea was widely mourned upon his death in 1913 at age 55, and a tribute song written by C.M. Duggan saluted Shea for his common touch: "Were the callers rich or poor, it was all the same, I'm sure / You treated them most courteous, one and all / Your smile dispelled their wrath, you cast roses in their path / As you bowed them out and thanked them for the call / Goodbye Billy, farewell Billy." (Courtesy Thomas Crane Public Library.)

Francis X. Bellotti

Few Quincy politicians have risen to the stature of the seemingly ageless Francis X. Bellotti. As state attorney general from 1975 to 1987, Bellotti was credited with a range of innovations, including the implementation of a merit-based hiring system that set a national standard. He was elected president of the National Association of Attorneys General, and he was awarded the association's Louis C. Wyman Award in 1981 as the most outstanding attorney general in the country. In 2013, the association granted Bellotti its lifetime achievement award. Bellotti was Massachusetts's lieutenant governor from 1963 to 1965 under Gov. Endicott Peabody. In a move that shook up Massachusetts politics, Bellotti ran against Peabody and won the primary election but then lost to former Republican governor John Volpe. It was a move many said cost Democrats the state's top office but one Bellotti did not regret. Bellotti served in the Navy during World War II and raised his 12 children in North Quincy and Wollaston after relocating from his native Boston. Regaled for a dynamic campaigning style and work ethic, Bellotti cofounded Arbella Insurance Corp. of Quincy, one of the largest insurance companies in the state, in 1988. At age 90, Bellotti still serves as the firm's vice president. The district court in Quincy was named after him in 2012 in a ceremony attended by legions of politicos who owe their careers to Bellotti, a bold intellect who always kept allegiance to his adopted hometown. (Courtesy Francis Bellotti.)

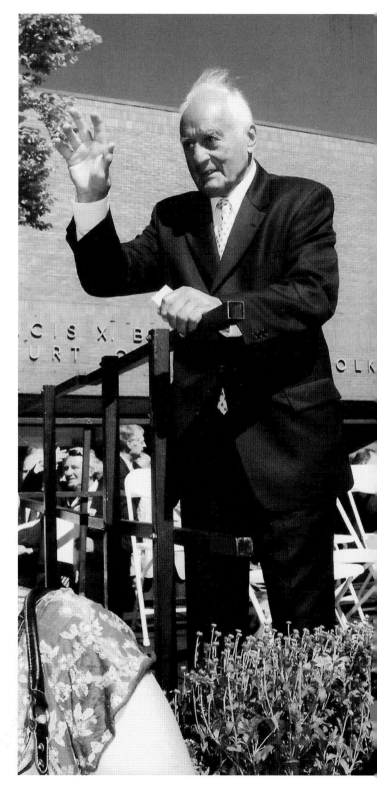

Michael G. Bellotti

The youngest son of Frank Bellotti, Michael has been sheriff of Norfolk County since 1998, and he is beloved for his impeccable wit and comedic timing. The Squantum resident's thought-out presentations at Quincy's annual St. Patrick's Day political roast are always a highlight. Bellotti also served three terms as a state representative. (Courtesy Francis Bellotti.)

Timothy P. Cahill

A native of West Quincy, Cahill served on the city council and ran the popular downtown lunch spot Handshakes before he was elected state treasurer, a post he held from 2003 to 2011. A headstrong politician known to go against the grain, Cahill left the Democratic Party to launch a failed independent bid for governor in 2010. A student of history, Cahill chronicled Quincy entrepreneurial success stories in his 1994 book *Profiles in the American Dream*. (Courtesy City of Quincy.)

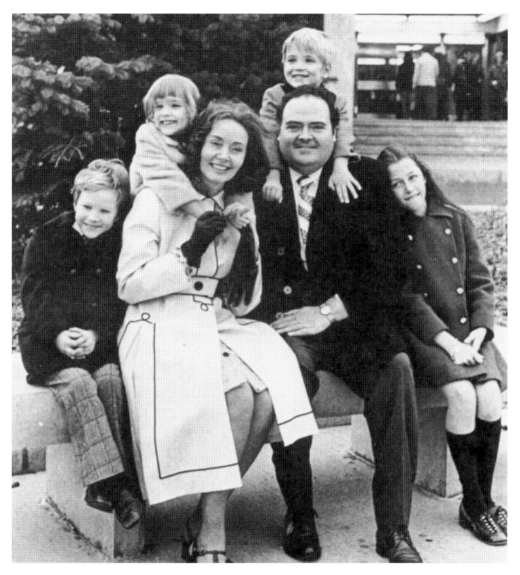

James R. McIntyre

Veterans of Quincy politics still talk about the "McIntyre Machine," the name ascribed to the network loyal to one of the most influential and accomplished mayors in city history. McIntyre, a Harvard graduate and Purple Heart recipient for his actions in Korea, was the son of a Quincy police captain. He was mayor from 1966 to 1971 and simultaneously served as the city's state senator on Beacon Hill. The quick-witted McIntyre saw through the expansion of Boston's subway line to Quincy Center in 1971 (station pictured in background), as well as the construction of new senior citizen housing, a library, and several federally funded improvements to neighborhoods and industrial districts. McIntyre died in 1984 at age 53 after suffering a heart attack. A proud family man, McIntyre was survived by (pictured) wife Sheila, two daughters (Elizabeth, pictured on her mother's shoulders, and Sheila at right), a son (Charles, at left), and legions of devotees he shepherded through the political world. His son William (pictured on his shoulders) died at age 19 after falling down an elevator shaft in Boston. (Courtesy Quincy Historical Society.)

78.27.1 C
Burgin, Thor

Arthur H. Tobin

Tobin left a large footprint on Quincy. The product of a family of 10, Tobin enrolled in the Marine Corps and went to law school before he was elected in 1968 to the city council, where he served for 10 years. Tobin was a lifelong ally of Mayor James McIntyre—born three days apart, the pair shared the same room at Quincy City Hospital as newborns. Tobin, who also served as a state representative and state senator, was mayor during a very difficult time in Quincy. The infamous "Blizzard of '78" struck a few weeks after he was inaugurated, Quincy Center's businesses were struggling to maintain vitality, and voters ratified a statewide proposition that dramatically changed how cities and towns levied property taxes. As mayor, Tobin oversaw the construction of landmark Quincy office buildings, the Stop & Shop headquarters in Quincy Center, and the National Fire Protection Association's headquarters in West Quincy. His children have served the city in a variety of capacities, from police officers to court clerks to legislators. Tobin was appointed clerk of courts by Gov. Edward King in 1982, and he still holds the post today, at age 82. (Courtesy Quincy Historical Society,)

Paul D. Harold
Harold was one of Quincy's most beloved politicians, known for his worldly, genteel style. Elected to the state senate in 1978, Harold, a history buff, oversaw the transfer of the Adams birthplaces from state to federal ownership for preservation. He helped Uganda draft its constitution as an American envoy and taught American studies at University College Cork in Ireland. He died of stomach cancer in 2002 at age 53. The Paul Harold Bridge in Quincy Center was named in his honor. (Courtesy City of Quincy.)

Tackey Chan
Wollaston native Tackey Chan made history in 2010 when he and a candidate from Saugus became the first Asian Americans ever elected to the state house of representatives. A leader in the city's thriving Asian community and the son of Chinese and Hong Kong immigrants, Chan was the founding board president of Quincy Asian Resources, Inc. (Courtesy Tackey Chan.)

Amelio Della Chiesa

A master plumber and the son of Italian immigrants from South Quincy, Della Chiesa (center) was mayor from 1954 to 1965 and was never defeated in a mayoral election. Della Chiesa was known for his practicality and conservative handling of city finances, and he oversaw Quincy during the height of its downtown retail boom. His nephew Ron is a well-known Boston disc jockey and radio personality. At left is Frank Remick, owner of Remick's Department Store, and at right is George Fay, a founder of the Quincy Christmas parade. (Courtesy Quincy Historical Society.)

William D. Delahunt

Delahunt, a US representative from 1996 to 2010, was the first son of Quincy to represent the city in Washington, DC, since John Quincy Adams. Delahunt was also a city councillor and state representative and served as Norfolk County district attorney from 1975 to 1994. While in Washington, Delahunt served on the International Relations Committee and worked with Venezuela to secure heating oil assistance. (Courtesy City of Quincy.)

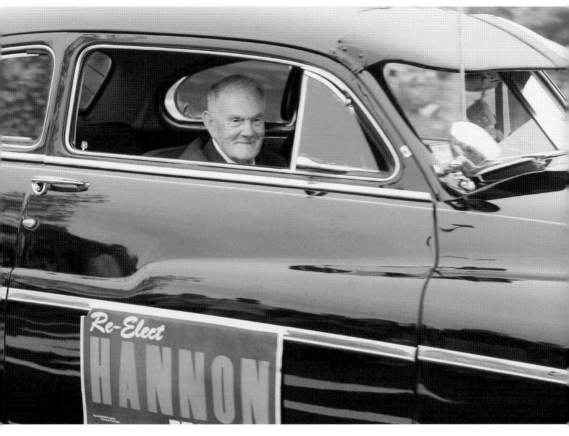

Walter J. Hannon

Hannon, who was mayor from 1972 to 1975, grew up in Houghs Neck and inherited his father's tire business after graduating from North Quincy High School in 1949. As a city councillor, Hannon served on the city's Industrial Development Commission under Mayor James McIntyre, whom he succeeded, and he developed a conviction that Quincy needed to broaden its commercial tax base in order to relieve tax pressure on home owners. Hannon was the leading governmental force in attracting the State Street Corporation office complex to North Quincy, which is now Quincy's largest employer and commercial taxpayer. Hannon also attracted the department store Jordan Marsh to build a warehouse in Squantum and opened up South Quincy to commercial development by seeing through the extension of the Boston subway to the area. In his 1971 campaign, Hannon famously pronounced it was "time the city got away from relying on General Dynamics to support the city," a reference to the final owner of the Fore River Shipyard, which closed 15 years after Hannon made the remark. Hannon worked as city planning director for a time after he lost the mayor's seat to Joseph LaRaia, and he was part of the team that developed West Quincy quarries into Granite Links Golf Course. In 2010, the city named a new roadway through Quincy Center after him, Hannon Parkway. (Courtesy City of Quincy.)

Francis X. McCauley

McCauley was mayor from 1982 to 1989 and approached politics with a studiousness that makes him the leading authority on Quincy's political history. A banker, McCauley grew up in Houghs Neck and raised his family on the same street on which he was born, Manet Avenue. He got involved in politics once he heard rumblings his home district might be targeted for urban renewal development. McCauley made several bold moves in his tenure, including reorganizing several departments and the school district, and he sued the state over the pollution of Quincy Bay from a sewage treatment plant. McCauley's 2000 book *Quincy, Massachusetts: A Political History* is an indispensable historical resource. (Courtesy City of Quincy.)

Michael W. Morrissey
Quincy's political class knew it had a player on its hands in 1976 when a 22-year-old college graduate named Michael Morrissey defeated a nine-term state representative in the Democratic primary. Morrissey would become one of Quincy's most wily and able politicians, representing the city in the state senate from 1993 until 2011, when he was elected Norfolk County district attorney. (Courtesy Quincy School Department.)

Clifford H. Marshall
Marshall famously never lost an election, and he held office from 1966 until his death in 1996. A Marine and athlete, "Kippy" Marshall was elected Norfolk County sheriff in 1974 and oversaw the construction of a new jail. As a city councillor, he would drive Ward 2 and call in potholes from his early-model car phone. The Clifford Marshall School in Quincy Point was dedicated to him. (Courtesy City of Quincy.)

Daniel G. Raymondi
An indefatigable advocate for his constituents, Raymondi epitomized the role of ward councillor. A Quincy Point native, Raymondi captained the Quincy High School football team and maintained a certain brawn in the political arena. First elected to three terms in 1976, Raymondi also served on the council from 1996 to 2011, and he led the city's Democratic committee for 12 years. (Courtesy City of Quincy.)

Patricia Toland
One of only six women to be elected to the city council, Toland rose from a parent-teacher organization (PTO) mom to school committee member and then respected councillor. She is the first and only female president of the council, presiding over the body in 1988 and 1989. She died in 1994. (Courtesy City of Quincy.)

Ronald Mariano

A former school teacher, Mariano rose to one of Beacon Hill's most powerful posts: majority leader of the state house of representatives. A Quincy Point native, Mariano served on the school committee from 1990 to 1999. In the statehouse, Mariano has championed health care reform measures and helped keep Quincy Medical Center open amidst severe financial strain. (Courtesy City of Quincy.)

Leo J. Kelly

Born and bred in Houghs Neck, Leo Kelly, a local barber, proudly represented his neighborhood on the city council in three different decades. A neighborhood fixture, Kelly fought to stop pollution of Quincy Bay from the faulty Nut Island sewage plant. A federal court judge ordered a $3.8-billion cleanup of the bay in 1985, a landmark case that stemmed from a city legal action. (Courtesy City of Quincy.)

Michael D'Amico
Young Michael D'Amico took the Quincy political scene by storm and then was gone just as quickly as he came. The youngest man ever elected to the city council, at age 20 in 1995, D'Amico formed the city's youth council when in high school. Many remarked that he carried himself like he was 30 when he was 17. The West Quincy native, whose grandfather owned a local barbershop, clearly drilled to be in politics. Some five years after he was elected, D'Amico got caught up an in FBI corruption sting and was ultimately convicted of taking a $2,500 bribe from a coffee shop owner who was cooperating with investigators. D'Amico served four months in prison and departed for Maine, where he lives today. Occasionally, he will make a surprise appearance in his hometown. (Courtesy City of Quincy.)

James A. Sheets
A native of Pennsylvania, where his father was a coal miner, Sheets came to Quincy in the early 1950s to study at Eastern Nazarene College. He represented a changing voice in Quincy and fared exceptionally well in a political climate largely populated by native sons. After eight terms on the city council representing Ward 4, Sheets first won election to the mayor's office in 1989, prevailing in one of the most pitched campaigns the city had seen. Upon election, Sheets expressed confidence in the future of the city because, he said, its people "know that trust is more important than the exercise of power." He made aggressive pushes to rebuild the Fore River Shipyard, including an ill-fated plan to manufacture and repair cruise ships there in association with a Greek company that was angling for guaranteed loans from the federal government. Sheets left politics in 2000 after coming up short in a recount election to William Phelan. Today, he teaches government as a professor at Quincy College. (Courtesy City of Quincy.)

William J. Phelan
Phelan was mayor from 2002 to 2008. The son of a mailman, Phelan himself carried letters while in law school. He burst onto the scene after a short school committee stint to unseat James Sheets, only the second time in city history that a candidate captured the mayor's seat without first serving on the city council. A basketball player, Phelan was known to occasionally pop into pickup games with city youth. (Courtesy Larry Norton.)

Thomas P. Koch
The son of Quincy icon Richard Koch, mayoralty was not necessarily pegged for Thomas Koch, who, like his father, ran the city's parks department. But in 2007, Koch resigned the post to run against his boss, William Phelan, sparking one of Quincy's most intense political rivalries. Mayor since 2009, Koch has focused on capital projects and the elusive revitalization of Quincy Center. (Courtesy City of Quincy.)

CHAPTER SIX

City of Neighborhoods

Quincy folks are proud of their city, but they are even prouder of their neighborhoods. From North to West to South Quincy, from Wollaston to Merrymount to Houghs Neck, from Quincy Point to Squantum to Germantown, each pocket has its own heritage and lore. In many cases, the stories behind the names of neighborhoods stretch back centuries further than Quincy itself.

Despite his name being ubiquitous in the city, not much is known about Capt. Richard Wollaston, the English seafarer who is said to have established a trading post on Quincy's shores. Ditto for the namesake of Houghs Neck, Atherton Hough, who was bestowed one of the original land grants in what would become Quincy. The Pilgrim-friendly Massachusett tribe leader Squanto is the namesake of Squantum, a historic peninsula that once hosted an airport that counted Amelia Earhart among its incorporators and was the site of a deadly, high-profile plane crash that killed spectacular female aviator Harriet Quimby.

Delve into Quincy's neighborhoods today and one will find a diverse array of legends, renowned for everything from scooping ice cream to flinging vinyl records through the air to achieving fame in Hollywood. Everyone in Quincy Point knows David Chew, a member of one of the first Asian families to settle in Quincy, who has run the Dairy Queen on Route 3A for over 40 years. Longtime residents still vividly remember Mike "The Winger," an epileptic who pedaled his bike through Quincy Center in search of the right vantage from which to gleefully "wing" vinyl records into the air like Frisbees. Perhaps it was the neighborhood's legendary theater, but for some reason, Wollaston has produced an array of stage and screen stars, including Ruth Gordon, Billy de Wolfe, and Dropkick Murphys.

Whether their impact stretched to end of the block or was felt across the nation, these neighborhood legends brought distinction to Quincy's enclaves.

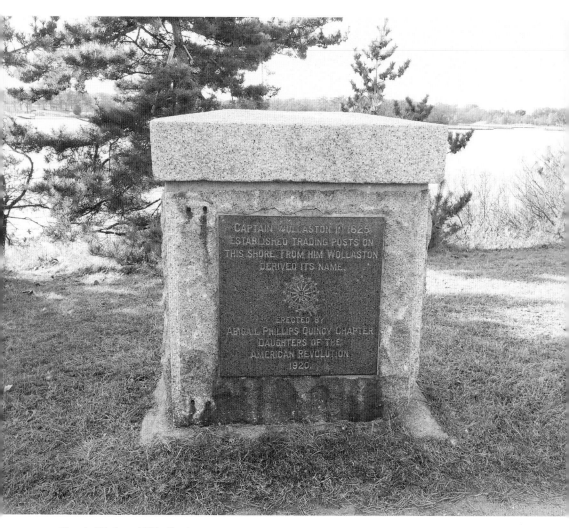

CAPTAIN WOLLASTON IN 1625
ESTABLISHED TRADING POSTS ON
THIS SHORE. FROM HIM WOLLASTON
DERIVED ITS NAME.

ERECTED BY
ABIGAIL PHILLIPS QUINCY CHAPTER
DAUGHTERS OF THE
AMERICAN REVOLUTION
1920.

Capt. Richard Wollaston
Little is known about the Englishman after whom one of Quincy's signature neighborhoods is named. Wollaston was drawn to the New World in 1625 by the lucrative fur trade and is said to have established a trading post near Black's Creek. The spot is marked by a headstone (pictured) at the corner of Furnace Brook Parkway and Quincy Shore Drive, which was installed by the Daughters of the American Revolution in 1920. Wollaston was apparently underwhelmed by the commerce he found and left after about a year, but his short stay was enough to brand the area Mount Wollaston. Most of what is known about Wollaston comes from the writings of Plymouth County governor William Bradford, who had a distaste for the hedonism and cavorting of Thomas Morton, an Englishman who came over on Captain Wollaston's fleet and renamed the area Mare Mont, or Merrymount, after Wollaston left. It is possible that Bradford embellished the significance of Wollaston's journey in order to not credit Morton. (Author photograph.)

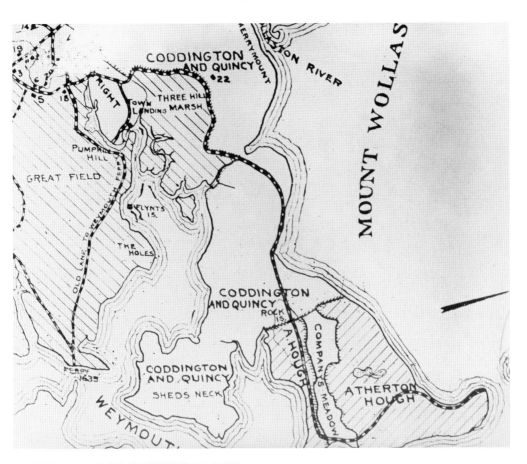

Atherton Hough

Atherton Hough was mayor of Boston, England, and came to the Colonies to freely practice his religion. He was the assistant to the governor of Massachusetts and a magistrate and, in January 1635, had 600 acres granted to him by the General Court in Boston (delineated in this map). While it does not appear that Hough ever lived on the land, it was forevermore known as Houghs Neck. (Courtesy Thomas Crane Public Library.)

Joseph Palmer

Quincy's Germantown section got its name from a 1750s experiment to establish a glass manufacturing hub there. Joseph Palmer, a Revolutionary War general, partnered with Richard Cranch to attract a host of skilled German glass workers to the area to live and work in a planned community they dubbed Germantown. The venture lasted about 10 years, eventually suffering from undercapitalization and fires. (Courtesy Quincy Historical Society.)

Uncle Sam Rounseville

In Houghs Neck, Sam Rounseville is known as a go-to realtor. But when there is a parade or other festive occasion in Quincy, he dons the red, white, and blue and becomes Uncle Sam, a mascot for Quincy's patriotic pride and a walking billboard for his commercial enterprises. Born Leroy Lincoln Rounseville, Uncle Sam was the son of a well-known Quincy florist. In 1991, he legally changed his name to Uncle Sam and branded himself "Salesman for America." The former textile salesman traveled far and wide in his top hat, suspenders, and tails, imploring folks to volunteer, whether they wanted to hear it or not. The passionate Uncle Sam has been ejected from Fenway Park for blocking people's views and shooed away from the Statue of Liberty for staging a photograph shoot there. He also traveled to the 1992 Winter Olympics in France to cheer on the Americans. The boy he is pictured with is Rounseville's grandson, Harry Ryan. (Courtesy City of Quincy.)

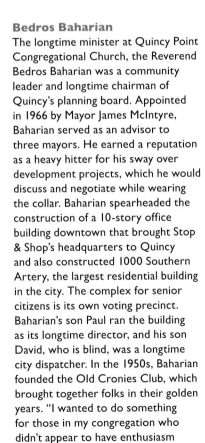

Bedros Baharian

The longtime minister at Quincy Point Congregational Church, the Reverend Bedros Baharian was a community leader and longtime chairman of Quincy's planning board. Appointed in 1966 by Mayor James McIntyre, Baharian served as an advisor to three mayors. He earned a reputation as a heavy hitter for his sway over development projects, which he would discuss and negotiate while wearing the collar. Baharian spearheaded the construction of a 10-story office building downtown that brought Stop & Shop's headquarters to Quincy and also constructed 1000 Southern Artery, the largest residential building in the city. The complex for senior citizens is its own voting precinct. Baharian's son Paul ran the building as its longtime director, and his son David, who is blind, was a longtime city dispatcher. In the 1950s, Baharian founded the Old Cronies Club, which brought together folks in their golden years. "I wanted to do something for those in my congregation who didn't appear to have enthusiasm for anything except their aches and pains," Baharian told the *Boston Globe* in 1960. Baharian died in 2000. (Courtesy Quincy Historical Society.)

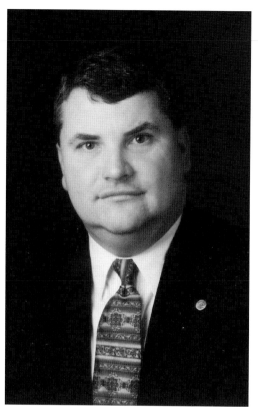

Michael McFarland
McFarland rose from the owner of Barry's Deli, a Wollaston fixture since 1961, to a city councillor, auditor, purchasing agent, and bank CEO. Quick with a friendly greeting and an offer of help, McFarland has contributed to several civic causes, including Quincy's Christmas Festival and Flag Day committees, the Rotary Club, and the Quincy Partnership. (Courtesy City of Quincy.)

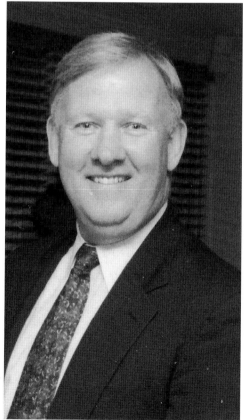

Edward Keohane
Keohane has comforted and served generations since 1965 as owner of Keohane Funeral Home, at 785 Hancock Street in Wollaston, with another location in North Quincy. The business was founded in 1932 by Keohane's father, Cornelius. A giant in Quincy civic affairs, Keohane was a founding member of the Quincy Partnership and helped launch Quincy's Flag Day parade, collecting the hundreds of miniature flags children wave as they march. (Courtesy Thomas Galvin.)

Dropkick Murphys

Renowned Celtic punk band Dropkick Murphys started in the basement of a former barbershop, which today is a cell phone store, at 654 Hancock Street in Wollaston (below). The band played after hours at the shop for about six months. The band's lead vocalist, Ken Casey, is from neighboring Milton, and original guitarist Rick Barton lives in Quincy. Barton gives his home city a nod by calling his current band, Continental, purveyors of "Granite City Rock 'n' Roll." The Dropkicks' song "I'm Shipping Up to Boston" has become a city anthem. The band is pictured here performing the song at the Boston Red Sox 2014 opening day at Fenway Park. (Both, author photographs.)

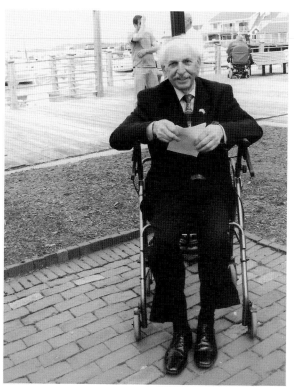

William Draicchio

For decades, thousands of Fore River Shipyard and Quincy Point commuters counted on the steady hands and quick feet of officer William Draicchio, who appeared to be dancing as he expertly directed traffic. The charismatic combat Marine spent 36 years working the intersection of Route 3A and Route 53, which was named after him shortly after he retired in 1989. (Courtesy Larry Norton.)

Thomas Kiley

Kiley is a seasoned lawyer who has developed a reputation as the go-to guy for embattled politicians. The Vietnam veteran and Harvard graduate lost function in his left hand when he was shot in the Mekong Delta, and he went on to argue before the US Supreme Court. A reserved barrister, Kiley is as proud of his days as North Quincy High School quarterback as any courtroom exploit. (Courtesy City of Quincy.)

David Chew
Decades before Quincy had a robust Asian population, David Chew's family immigrated to the city from China in 1938. He soon found a foothold, taking the helm in 1967 of the popular Dairy Queen on Washington Street in Quincy Point where he started working as a high school freshman. Chew has scooped cones for generations of Quincy youngsters and hired many for their first jobs. (Courtesy David Chew.)

Robert Curry
Curry Hardware is one of Quincy's longest-tenured family-owned businesses. Robert Curry's parents, Paul and Grace, opened the shop in 1945, and after the original location burned in a fire, the current Copeland Street location in West Quincy opened in 1964. Robert took over in 1975, and he thrived as giants like Home Depot cropped up all around him. Curry is also an exemplary contributor to civic causes. (Courtesy South Shore Chamber of Commerce.)

Mark Bertman

Operating in Quincy Center since 1944, Rogers Jewelers is the last remaining link to the area's "Shopperstown USA" heyday. It is personified by Bertman, who has owned the shop since 1960 and still works the counter with his wife, Isobel. Bertman has served on a host of civic committees. At right is Lloyd Lillie, the sculptor who created the John and Abigail Adams statues in Quincy Center. (Courtesy Thomas Galvin.)

Robert Foy III

The Foy family owned the first modern supermarket in Quincy, Foy's Market in Quincy Center, and they were committed to public service. Robert Foy III exemplified that, transitioning from running the market with his brother Dick to a career as the city's treasurer and auditor from 1972 to 2005. A city hall conference room is named after him. (Courtesy City of Quincy.)

Bill Dana

Viewers of *The Steve Allen Show* in the 1950s and 1960s who were entertained by the bumbling, thickly accented character "José Jiménez" were witnessing Quincy High School class clown William Szathmary at his best. Szathmary grew up on Glendale Road and Elm Street in the center of the city, where his mother ran a bridal shop. He left Quincy after college to pursue a show business career in New York. He changed his name to Bill Dana, a play on his mother Dina's first name, and wrote for comedians like Allen and Don Adams. After the Jiménez character earned him acclaim, NBC green-lit *The Bill Dana Show*, which was on the air from 1963 to 1965. Dana was revered back home, where a "Bill Dana Day" was celebrated in the 1960s. On May 5, 1961, astronaut Deke Slayton uttered the first words from Earth to an American in outer space, telling Alan Shepard, "OK, Jose, you're on your way!" This was a nod to José Jiménez, whom Dana portrayed at times as an astronaut and often as a bellhop. As the tapestry of America changed, people questioned if the José Jiménez character was insensitive toward Hispanic Americans, and Dana proactively dropped the act in 1969. "José Jiménez was not murdered, he committed suicide," Dana joked to the *Patriot Ledger* in 2006. He continued to contribute to comedy, founding the American Comedy Archives at his alma mater, Emerson College. He lives in Nashville with his wife, Evelyn. (Courtesy Bill Dana.)

Dick Dale

Growing up on Shea Street in Quincy Point, Richard Monsour dug for clams and fished for eels in the Fore River, and, as a daring teenager, he swam all the way to Germantown. He took risks as a musician as well. After leaving Quincy High School and moving to California with his parents, Monsour, a guitarist, took to surf culture and set about innovating surf music, a reverb-heavy genre to which the Beach Boys and many others belong. Monsour changed his named to Dick Dale and found fame as the "King of the Surf Guitar." His signature track, "Miserlou," was immortalized as the theme song of the 1994 movie *Pulp Fiction*. Dale maintains an affinity for Quincy, returning in 2005 to give a talk about his career and his memories of growing up in the city. (Courtesy Quincy Historical Society.)

Ruth Gordon

In October 1896, Dr. John Gordon, one of the founders of Quincy City Hospital, was summoned to the Jones home on Marion Street in Wollaston to assist with a difficult birth. Complications arose, and Gordon resigned himself to having lost the newborn. He set the baby aside and began to focus on saving the mother's life. Suddenly, there was a sign of life from the baby girl, and her jubilant parents decided to name her Ruth Gordon Jones after her doctor. Ruth Gordon (she shortened her name for films) acted in a range of pictures in her nearly 50-year Hollywood career, including *Rosemary's Baby* and *Every Which Way But Loose*, in which she played Clint Eastwood's mother. One of Quincy's most celebrated daughters, the amphitheater in Merrymount Park was named after her, and she regularly attended her Quincy High School class of 1914 reunions. Gordon references Quincy in her screenplay *The Actress*, which mirrors her journey as the daughter of a sea captain to stardom. She was an only child whose mother died relatively young, shortly after she went to New York to pursue acting. Ruth Gordon died in 1985 at age 88; her *New York Times* obituary called her "an actress and writer whose perpetual energies seemed to defy time." (Courtesy Quincy Historical Society.)

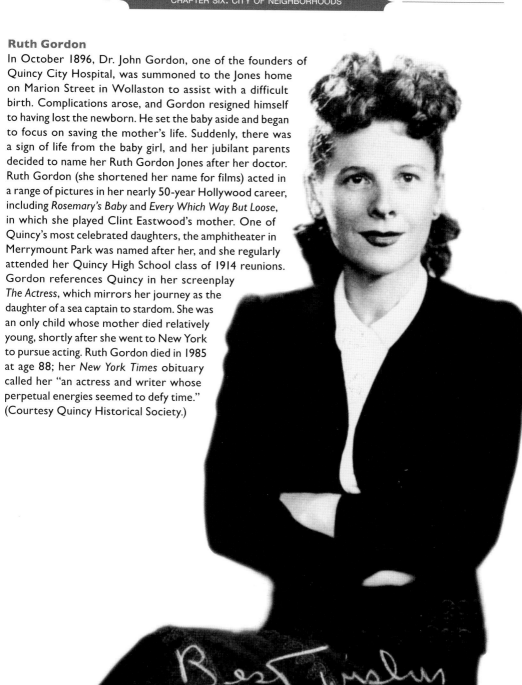

Billy de Wolfe

William Jones, born on South Central Avenue in Wollaston, borrowed his stage name from New England–area vaudevillian Billy De Wolfe and had a 30-year stage and screen career, mostly as a character actor. His trademark tones can be heard every Christmas as the voice of the hapless Professor Hinkle in the *Frosty the Snowman* animated television special. He died in 1974 at age 67. (Courtesy Quincy Historical Society.)

Jake Kilrain

Boxing fanatics still make pilgrimages to St. Mary's Cemetery in West Quincy to visit the grave of Jake Kilrain, a boxer who famously tangled with the vaunted John L. Sullivan in 1889 in the final bare-knuckle heavyweight title fight. Kilrain's grave references his loss to Sullivan, an excruciating bout. He died in 1937 at age 78 in Quincy, where he worked as a shipyard night watchman following his retirement. (Author photograph.)

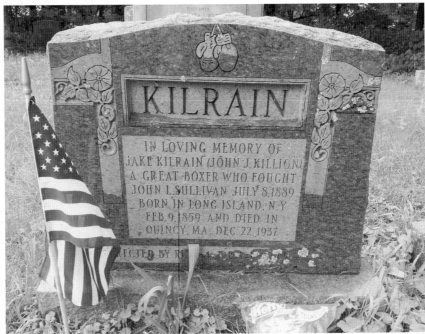

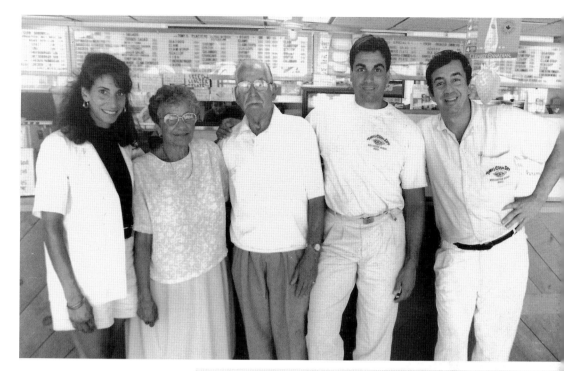

Tony Kandalaft

Since 1964, Tony's Clam Shop has been as much a fixture of Wollaston Beach as the Boston skyline. The restaurant was founded by Lebanese immigrant Tony Kandalaft (center) and his wife, Tillie (second from left), who opened up shop on the first floor of their home on Quincy Shore Drive. Also pictured are their children, Karen Djerf (left), Gary (second from right), and Roy (right), who also run the restaurant. Originally a simple walk-up stand, Tony's has a consistently packed patio overlooking the beach on summer days, and the 95-year-old patriarch can still be seen working the floor. (Both, courtesy the Kandalaft family.)

Christa Hagearty

When fire destroyed the Dependable Cleaners hub office on Quincy Avenue in 2012, generations' worth of keepsakes of the family business were lost, but hope was not. CEO Christa Hagearty, whose grandfather founded the business in 1944, rebuilt the location in Quincy Point, an unflinching response that inspired the business community. (Courtesy South Shore Chamber of Commerce.)

Joe Newton

The unfailingly cheery Newton, a lifetime fixture in Squantum, brings an energy all his own. A resident of Aberdeen Road, where he leads the neighborhood charge every winter to freeze over backyards for ice skating, Newton is the son of a newspaper ad man, served on the city council, and once ran for mayor. He is one of the most prolific joke tellers in Quincy. (Courtesy City of Quincy.)

Stephen O'Donnell

North Quincy High School graduate Stephen O'Donnell was revered as one of the gurus of Massachusetts's transportation infrastructure. He was put in charge of the unwieldy merger of the state's highway department and turnpike authority, and his ability to stealthily supervise job sites earned him the nickname "the Secret Squirrel." He was stricken with cancer and died in 2010 at age 47. (Courtesy City of Quincy.)

Ed Kane

The ethic that helped North Quincy native Ed Kane amass a nightclub and restaurant empire was groomed at his father Charlie's bar, Kane's Place, in Quincy Point, which catered to shipyard workers. Kane purchased several staple South Shore restaurants and developed many others, including a combined nightclub and bowling alley at Foxwoods Casino in Connecticut. (Courtesy South Shore Chamber of Commerce.)

Stephen McGrath

A model of levelheadedness in the temperamental world of Quincy politics, McGrath carried himself with a control and collegiality that won him allies across the spectrum. After he lost a 1989 bid for mayor, he was hired as solicitor by his opponent, James Sheets. McGrath, who lived on Bass Street most of his life, served in a variety of city capacities until his untimely death the week before his 60th birthday. (Courtesy City of Quincy.)

Daniel Quirk

Quincy auto magnate Dan Quirk in many ways holds the keys to the future of the Fore River Shipyard, of which he is a majority owner. A pipe fitter before venturing into car sales, Quirk's name is ubiquitous in Quincy Point and over the line in Braintree, the site of his first dealership. Quirk contributes to many charitable causes and has sponsored several city fireworks displays. (Courtesy South Shore Chamber of Commerce.)

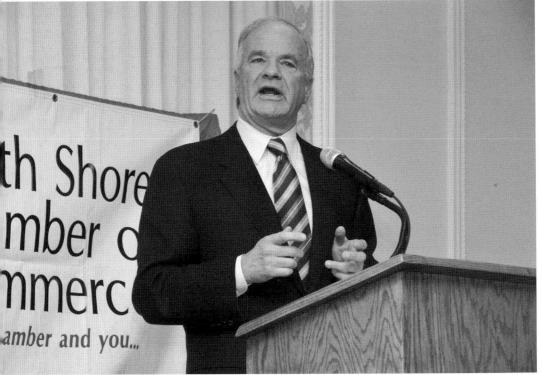

Phillip Keenan

Phillip Keenan and his wife, Loretta, raised children who became central to Quincy. His son Paul is the city's police chief, his son John is a state senator, and his daughter Christine is the city's first lady, having married future mayor Thomas Koch. Keenan's parents both died when he was six, and he was raised by his brothers and sisters in the South Boston housing projects. While raising his family on Lincoln Avenue in Wollaston, Keenan worked nights for 52 years in the mailing room the *Boston Herald Record American*, and he died at age 86 in 2003. (Courtesy City of Quincy.)

Raymond Thompson

For years after the Quincy shipyard in Quincy Point closed, Raymond Thompson still stood watch. The Oklahoma native worked security for decades at the property and was retained after manufacturing ceased by a quasi-state agency that operated there. Thompson lived on Gilmore Street, served in both World War II and the Korean War, and was a retired chief gunner's mate. He died in 2001 at age 73. (Courtesy Thomas Galvin.)

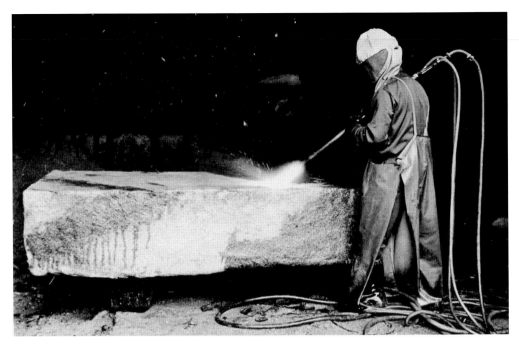

Edward Monti

Perhaps the last vestige of Quincy's stonecutting heritage is on Centre Street in Southwest Quincy, where Ed Monti's eye-catching creations are displayed on a lawn across the street from his offices. Monti Granite Co. was founded by Monti's father, Angelo, in 1919 after he emigrated from Italy, and today, it is run by his sister Linda. Monti uses flame torches to carve stone into a range of whimsical shapes and sizes. Posing with his pumpkin creation, Monti (left) is pictured with Mayor Thomas Koch. Monti crafted the fountain outside Merrymount Park as well as an odd, modernist piece to mark Quincy's 300th birthday that sits in a park along Burgin Parkway. "I would imagine something and think, 'Let me see if I can do it,' " Monti told the *Patriot Ledger* in 2010. (Above, courtesy Quincy Historical Society; below, courtesy City of Quincy.)

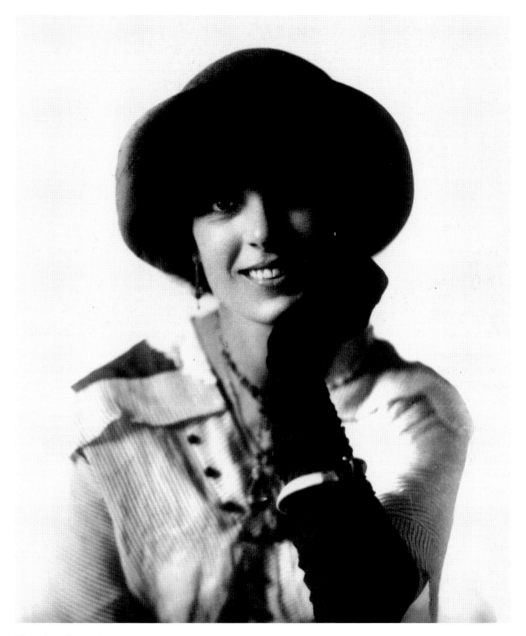

Harriet Quimby

In 1912, a well-dressed crowd gathered excitedly for the Boston Air Meet at the old Squantum airfield. They were there to catch a glimpse of Harriet Quimby, America's first licensed female pilot, who was set to race West Coast rival Blanche Stuart Scott and then embark on an air trip to New York. Before the race, Quimby took William Willard, the manager of the air meet, up for a spin in her two-seat Bleriot airplane. As she circled around from Boston and approached the Neponset River, Quimby's plane took a sudden nosedive, and she and her passenger crashed into the sea, killing them both. The exact cause of the crash was never determined. The tragedy was mourned nationally, and Quimby, a Michigan native who wrote screenplays and edited a magazine, was forever linked to Quincy. (Courtesy Quincy Historical Society.)

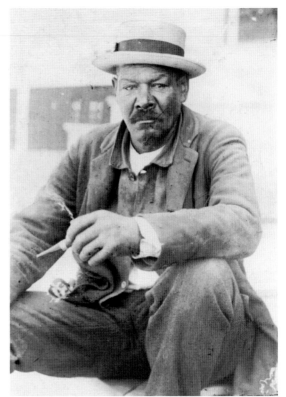

Squantum Joe

"Squantum Joe" Coleman came to Squantum from the British West Indies in the 1880s to work on a sewer project. He built a home of driftwood on the corner of Bellevue and Sonoma Roads and did favors for residents, who repaid him with meals and hospitality. A drinker, Coleman was known to break out in song in public, and he died in the mid-1920s in his makeshift manse. (Courtesy Quincy Historical Society.)

Walter Kendall

Kendall was a noted horticulturist credited with developing many new strains of fruit and plant life. On his Atlantic Street estate in North Quincy, Kendall experimented with many growing techniques. His property, which included an incredible geologic feature called a kettle hole, was gifted to the city in 1938. A bon vivant and avid cyclist, Kendall also bred Boston terriers. He died in 1946 at age 92. (Courtesy Quincy Historical Society.)

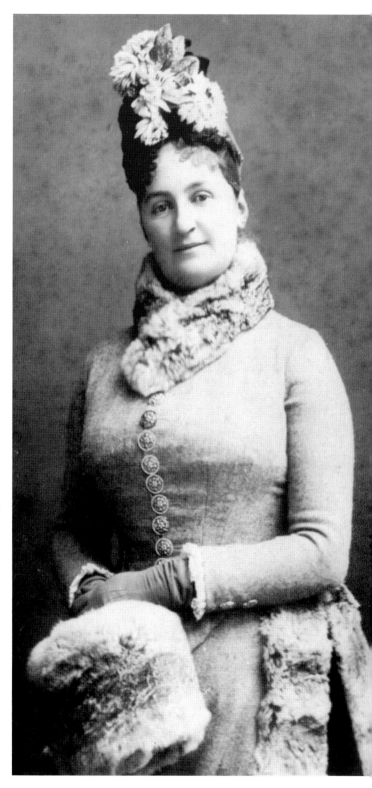

Lillie Titus
"The Grand Lady of Squantum,"
Lillie Titus was one of the
most prominent landowners
in Squantum in the late 1800s.
Born Lillie Blanche Huckins,
Titus inherited the estate of her
grandfather Capt. James Huckins
and later married Nelson Titus. A
crusader for preserving history,
Titus served as the first regent of
the Adams Chapter of the group
Daughters of the Revolution,
who were permitted to use
John Quincy Adams's birthplace
to conduct meetings. Titus
championed the refurbishment
of the birthplaces and is
credited with spearheading the
construction of the Abigail Adams
Cairn on Penn's Hill. She is also
credited with lobbying successfully
to bring the USS *Constitution*,
which played a pivotal role in
the War of 1812, back to Boston
for public enjoyment. (Courtesy
Quincy Historical Society.)

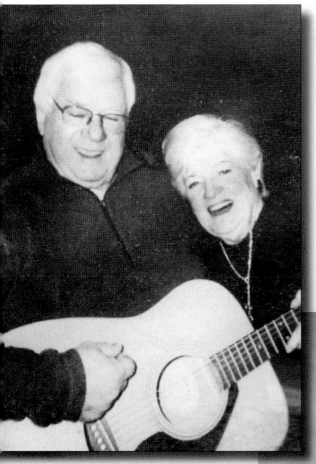

Jimmy McGettrick

When musical giants like Louis Armstrong, Loretta Lynn, and Bobby Darin were in Boston, they also wanted to play Quincy because of Jimmy McGettrick. The charismatic promoter was the heart and soul of the Beachcomber music club on Wollaston Beach, or, as traveling musicians knew it, "Jimmy's Place." McGettrick and a partner opened the Beachcomber in 1959 and, over the decades, hosted local and national music legends, from Tiny Tim to Dropkick Murphys. McGettrick, who bought his share of the club using $25,000 he made selling Christmas trees, died after a battle with cancer at age 77 in 2011. The woman he is pictured with is unidentified. (Left, courtesy the McGettrick family; below, author photograph.)

Michael "The Winger" Zadrozny
Everyone who came of age in Quincy in the 1960s and 1970s remembers Mike "The Winger" Zadrozny, but he was always shrouded in mystery. An epileptic with limited verbal skills, most did not even know Zadrozny's real name, and speculation about his backstory sometimes reached mythical proportions. They knew Zadrozny for his unique ritual of flinging vinyl records through the air in Quincy Center after pedaling in on his bike. Like Zadrozny, no one seemed to know exactly where the records came from. The son of Ukrainian immigrants, Zadrozny grew up on Dysart Street, and he loved to ride his bike throughout the city. Whenever neighborhood youths spotted him clutching records of the day's hottest musical acts, like the Beatles, Connie Stevens, and Glenn Campbell, they would gather around to hear Zadrozny hold court on the music's merit. No matter the artist, Zadrozny would inevitably declare that they "gotta go" and then launch the record like a Frisbee. While occasionally the subject of mean-spirited ridicule, Zadrozny was beloved by a generation who responded to him as a kind of "Pied Piper" of Quincy. A lifelong patient at Children's Hospital in Boston, Zadrozny died at the hospital at age 31 in 1977 after suffering an apparent stroke while out to dinner with his family. (Courtesy Phyllis Berlucchi.)

INDEX

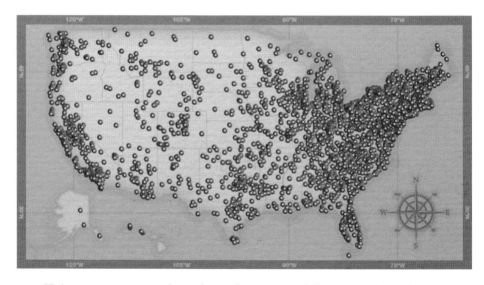